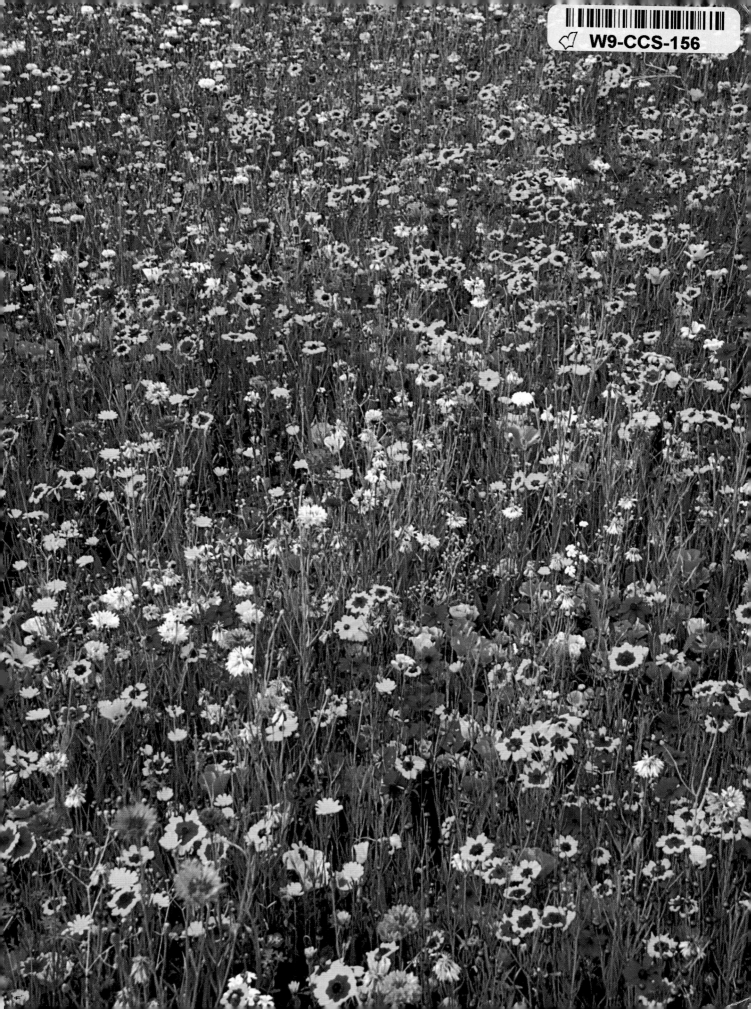

Design, Color & Composition in Photography

BRYAN PETERSON

LEARNING TO SEE CREATIVELY
REVISED EDITION

AMPHOTO BOOKS

An imprint of Watson-Guptill Publications

Acknowledgments

I'd like to thank the thousands of photographers
who purchased the previous edition of this book,
as well as my former editor, Robin Simmen;
senior editor, Victoria Craven; current editor,
Alisa Palazzo; and designer, Bob Fillie.

First published in 2003 by Amphoto Books
an imprint of Watson-Guptill Publications
a division of VNU Business Media, Inc.
770 Broadway, New York, NY 10003
www.watsonguptill.com

Senior Editor: Victoria Craven
Project Editor: Alisa Palazzo
Designer: Bob Fillie, Graphiti Design, Inc.
Production Manager: Hector Campbell

Library of Congress Cataloging-in-Publication Data
Peterson, Bryan F.
 Learning to see creatively : design, color & composition in photography /
 Bryan Peterson.— rev. ed.
 p. cm.
 Includes index.
 ISBN 0-8174-4181-6 (pbk.)
 1. Composition (Photography) 2. Photography, Artistic. 3. Picture perception. I. Title.
 TR179.P47 2003
 771—dc21

 2003010501

Printed in the United Kingdom

1 2 3 4 5 6 7 8 / 10 09 08 07 06 05 04 03

To my beautiful wife, Kathy,
with whom I will be in love forever

CONTENTS

INTRODUCTION

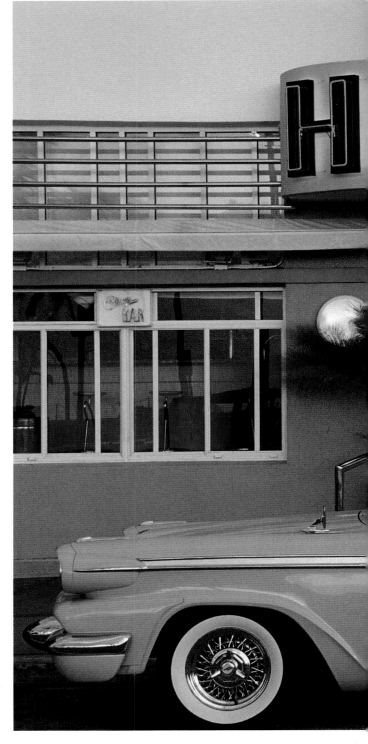

"Do you see what I see? Do you hear what I hear?" It's the Christmas season, and in the background my radio is tuned to a station playing that Christmas song. The timing couldn't be better as I sit down to write the introduction to this completely revised edition of my book *Learning to See Creatively* (Amphoto, 1988). Do you see what I see? Maybe, maybe not. Even if you're standing right next to me and I see something that I want to share with you, you still may not see it until all that remains is a glimpse. My daughters both spotted a hot-air balloon up in the sky the other day. It wasn't until it was almost out of sight that I finally spotted it, but by then it was merely a dot in the vast sky. It was frustrating for all of us, to be sure.

What does this story have to do with picture taking? It is analogous to picture taking and creative vision. All of us who are blessed with sight can see, but why is it that someone right next to us can *see* something of interest, yet we somehow miss it? If you've ever participated in a photography workshop in the field or gone out shooting with a friend from the local camera club, you know what I mean: Standing at the head of a trail you are bewildered, lost, and confused, while within minutes someone else is setting up a camera and tripod three feet away, zeroing in on a graphic composition of autumn-colored leaves. You watch in amazement and ask the most often heard question at workshops and field trip outings: "Why didn't I see that!?"

The answer may be a combination of things. Perhaps you were preoccupied with thoughts about your job, or hadn't dressed appropriately for the location and were shivering like crazy. Not being able to *see* is probably the greatest hurdle every photographer has to overcome. However, even once you begin to see—really *see*—you are faced with the next hurdle: composing all that great stuff in a balanced and harmonious fashion.

I know of no real rules that one must follow to *learn how to see,* but I do know of many, many principles and techniques that are designed to *help you see.* The aim of this book is to not only teach you how to recognize a picture-taking opportunity but also to challenge that conservative way of seeing that often leads to dull, ordinary photographs. Throughout this book, many of the

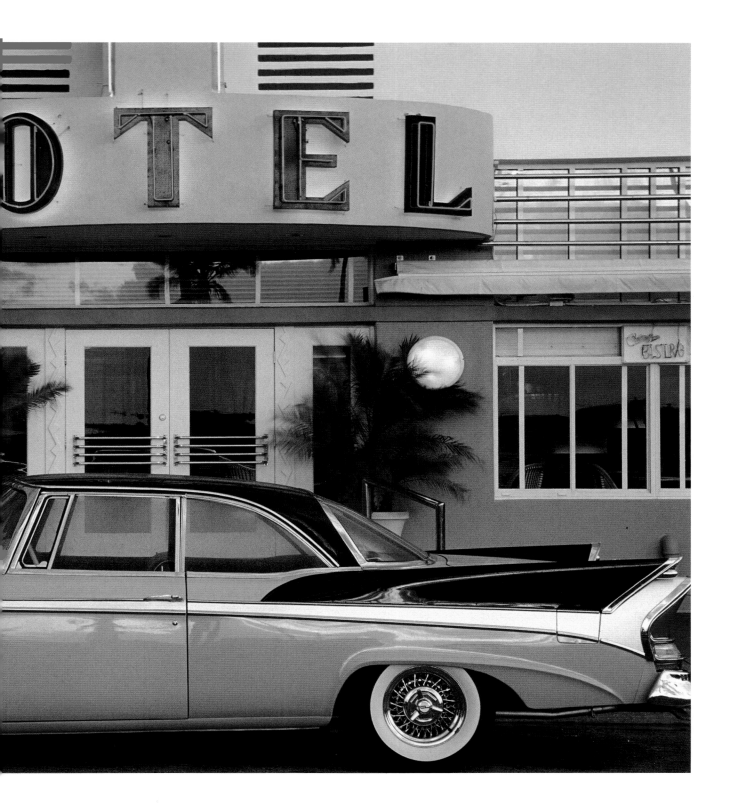

examples are pairs of images that show you before and after, as well as good and better. These pictures are certainly not intended to be the right way, but simply my interpretation of a particular scene at that particular moment in time.

Fifteen years have passed since *Learning to See Creatively* was first published. So much has changed, thanks in large measure to the many, many innovations of the photography industry. I recall joking at a seminar I taught back in 1990 that I was waiting for the industry to come out with a 20–400mm F2.8 zoom lens with ED glass and internal focusing. Although there is still no such lens on the market today, I can truthfully say that one day we will see just such a lens. Today, you can leave the house and head for the mountains or beach with no more than a camera and two lenses, and be ready for any subject that crosses your path—whether it be a close-up of a butterfly, the distant brown bear, or that big ball of orange flames setting in the western sky. Due to optical advances in the zoom lens arena, zoom lenses now rival and compete head to head with the once-favored sharper single-focal-length lenses.

However, the challenge still remains: To advance your personal vision, you must really practice and also exploit the vision of your lenses, no matter their zoom ratio or amazing sharpness. This all-new edition of *Learning to See Creatively* explores the subject of personal vision in great depth, with accompanying exercises throughout that promise to unleash the visionary in you—regardless of technology. Whether you're using film or, like many photographers, not bothering with film anymore and instead shooting everything digitally, as the old saying goes, "The more things change, the more things stay the same." Although I am the first to embrace change, using it is another matter. Even if I did employ the latest and greatest camera, lens, or photo-imaging software program, it would have very little impact on the one vital ingredient that separates a ho-hum image from an OMG ("Oh my God!"): creativity.

Creativity is perhaps best described as a combination of inventiveness, imagination, inspiration, and perception. The photography industry has yet to introduce a camera that searches out unique and interesting subject matter. There still isn't a camera that will alert you to the

two other compelling compositions that lie in wait next to the one you're currently shooting. There still isn't a camera that instinctively recognizes the "decisive moment." And, there still isn't a camera that will systematically arrange your composition in a balanced and harmonious fashion *before* you expose it digitally or on film. These are challenges that continue to be part of the wonderful world of image making, challenges for which the sole responsibility of success or failure rests squarely on your shoulders.

When I wrote the previous edition of *Learning to See Creatively,* I had one goal in mind: to dispel the myth that the art of image making was for the chosen few. Based on the overwhelming and positive responses I've heard at my many workshops and on-line courses, as well as contained in the many letters and e-mails I've received, I feel I reached that goal. This all-new, completely rewritten and reillustrated edition promises to continue to dispel the myth. In addition, I've added a section on color in the "Elements of Design" chapter, and I discuss in depth not only color's value as a design element, but also its impact on our mind and emotions. And again through the use of comparison images, you'll see the value of focusing your vision on line, shape, form, texture, and pattern, and how these elements are a strong force in creating truly compelling photographic compositions.

Learning to see creatively is also *very* dependent on what your camera and lens can and cannot see. Captains of ships need to become very familiar with their maps as they navigate the world, making certain to keep the ship pointed in the right direction. In much the same way, your lenses are maps that can lead you to new and enchanting lands. With constant practice, which comes by placing the camera and lens to your eye, you'll begin to visually memorize the unique vision of each and every lens—both the pluses and the minuses. The more you do this, the less likely you'll be to ever see the world in the same way again. You'll learn just how vast an area a wide-angle lens can cover, or how a telephoto lens can select a single subject out of an otherwise busy and hectic scene. It won't be too much longer until you'll find yourself knowing, without hesitation, what lens to use as you see one picture-taking opportunity after another.

Then, you can begin to take this newfound vision to even greater heights, challenging yourself to view the forest from a toad's point of view, or the city streets from a sidewalk point of view, or your backyard from a robin's-nest point of view. (Ladders are not just for house painting.) Lie on your back at the base of a large fir tree and show me the point of view of the squirrel that raced up it only moments ago. Set your camera on the shoulder of the road, and fire away just as the big semi truck comes into view. A composition like this will, for example, make it dramatically obvious why it is so important that the city council build a small underpass for the ducks that cross that busy road every spring.

Whether or not your compositions are compelling depends not on some magic recipe, but rather on a thorough understanding of lens choice, point of view, elements of design, and final arrangement, or composition. All of these are, as I said, "maps" that require studying, some more then others. Both your fears and preconceived notions will be challenged. How will you ever share with others the robin's-nest viewpoint if you're afraid of heights? How will you share the busy sidewalk view if the idea of lying down on the sidewalk is too intimidating? You'll certainly hit a "reef" now and then, and you may even feel compelled to abandon ship at times.

This is perfectly normal and to be expected. And, for that reason, the exercises in this new edition are designed to help you get free of the reef and back on course. There are certainly times of bad weather, or lousy light, or a limited choice in subject matter, but these exercises will certainly dispel the myth that "there is nothing to shoot."

There's a great deal of material in this book that addresses the what, where, and why of successful image making. This is a book about ideas—ideas from the river that flows through all of us. It is my intention to help you find the knowledge of where to fish, the courage to cast your net, and the strength to pull in your catch and harvest those ideas. This is not a book about metering for the right exposure, or setting the right *f*-stops and shutter speeds. That information can be found in my other book, *Understanding Exposure* (Amphoto, 1990).

Most of all, have fun with the enclosed material and don't become preoccupied with "doing it right"; if there's one thing my students and peers have taught me over the years, it's that there are no formulas or recipes in the pursuit of image making. It's all about observation and thought. As Henry David Thoreau once said, "The question is not what you look at but what you see."

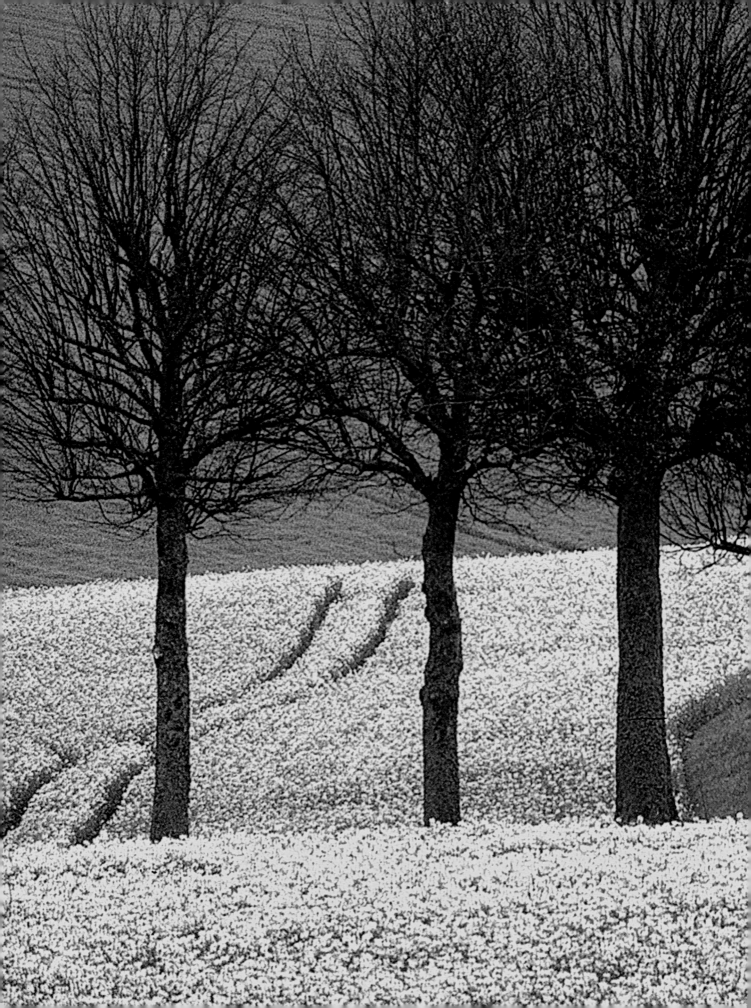

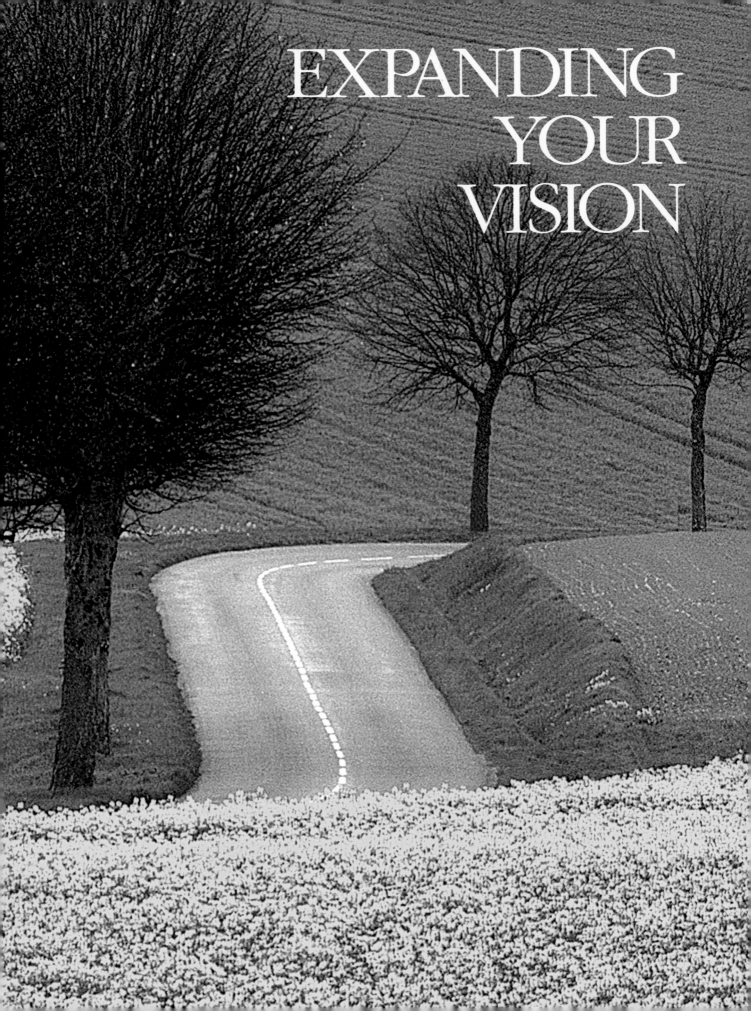

EXPANDING YOUR VISION

How Do We See?

The human eye sees in much the same way as a 50mm lens, and therefore, the 50mm focal length lens is appropriately called a *normal lens*. Unlike the eyes of the Six Million Dollar Man, the real human eye cannot zoom out and bring distant objects closer or see the world in "fish-eye" vision with the flick of a switch.

In photography's early years, much if not all of the picture taking was done with normal lenses. Of course, a lot has changed since those early days. There now exists a proliferation of single-focal-length lenses, ranging from full-frame fish-eye to a whopping 2000mm telephoto, and an almost equal number of variable zoom lenses. In addition, there is also the fascinating world of macro, or close-up, photography.

In my early years as an amateur photographer, I had nothing more than a 50mm lens and a Nikon camera body. Financial reasons kept me from buying an additional lens for quite a while. Finding myself in the position of owning just one lens, I soon realized the need to physically walk closer to my subjects to better fill the frame. I also learned how changing my point of view could invoke a greater sense of participation with my subjects when I met my two-year-old cousin at her eye

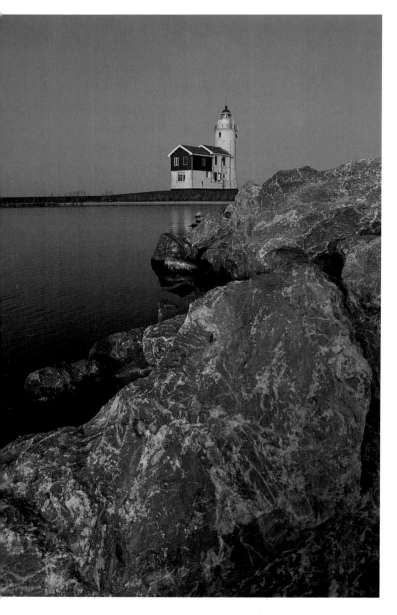

The Marken Lighthouse, located on the Iselmeer in North Holland, is but one of literally thousands of subjects that you can photograph from a multitude of viewpoints with a multitude of different focal length lenses. Factor in the change of seasons, and the shifts in light and point of view throughout the day, and it's clear how easily an entire book could be written on just a single subject.

After walking out some distance atop the rocky jetty, I chose a low viewpoint in a vertical frame to emphasize the shape, form, and texture of the rocks (left). Holding my camera and 20mm lens (rather than using a tripod), I set the aperture to f/16 and adjusted the shutter speed to 1/60 sec. Note how the 20mm lens, combined with a low viewpoint, creates a feeling of depth and perspective that's further emphasized by the curvilinear thrust of the rocks.

I then changed to the other side of the jetty and made a horizontal exposure (opposite). Note how after changing position I lost the sidelighting on the rocks.

[Both photos: 20mm lens, 1/60 sec. at f/16]

level as I followed her around the backyard. After climbing the stairs of a ten-story parking garage, I discovered a new and exciting vision shooting down to the street below. It wasn't long after that one experience that I began climbing trees and shooting down on numerous nature-filled landscapes.

I also have a vivid memory of the first time I looked up with my 50mm lens. After spending most of one morning shooting autumn leaves on the ground in a large aspen grove, I decided to take a break. While lying on my back, I reached for my camera just to take a look at the canopy of trees and blue sky overhead. Wow! My need for a break ended immediately! Then, at some point, I even learned that I could render a background of tones of muted and out-of-focus color simply by focusing as close as possible and using the biggest lens opening. Little did I realize back then just how valuable these lessons were.

In my on-location workshops and in my Internet photography courses, it continues to be apparent that most students are not familiar with the inherent visions that lie within their complement of lenses. As far as I'm concerned, the *only*—and the quickest—way to expand one's vision is by doing the necessary "eye exercises." After looking at the examples on these two pages and the next ones showing the variety of ways to see just one subject, try the exercise in the box on pages 16–17, which always proves to be most revealing to my students. For those of you shooting film, this exercise uses less than thirty-six exposures.

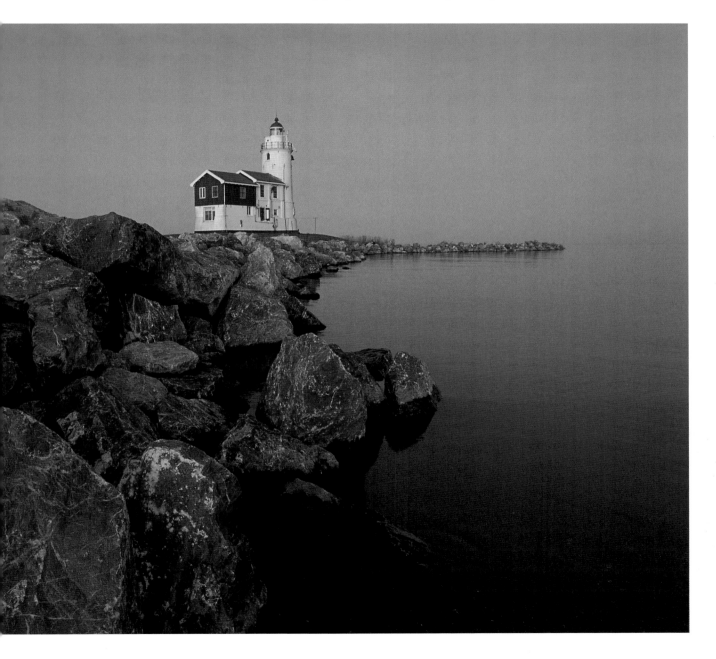

Exercise: Knowing What Your Lenses See

Whether you work digitally or with film, photography allows you to create a "vision." How do you achieve the vision? In large part by knowing what your lenses see. Chances are very good that you have one of those "street zooms" (see page 26). Depending on your lens type, set the focal length to either 28mm or 35mm, and make a point to *not* change this at any time during this exercise. Now choose a subject (a favorite barn or oak tree) or take your spouse, friend, or child into the backyard or over to the local park. From whatever distance is necessary to do so, place your subject so that it falls in the middle of the frame, allowing for a lot of "empty space" above, below, and to both sides. With the camera still at your eye, make your first exposure and then begin walking toward your subject. Every five paces, take another exposure, mindful of course to keep the subject in focus. Keep walking closer until your lens can no longer capture the subject in sharp focus.

One thing is sure to result from this exercise. Your first composition will record not only your main subject, but all of that *other stuff* that probably detracts from it, and your final composition should record a close-up of your subject, which not only cuts out that other stuff but maybe cuts out some important stuff, too.

Now, without changing the focal length, repeat the exact same exercise while on your knees and then again while on your belly. Finally, once you've gotten

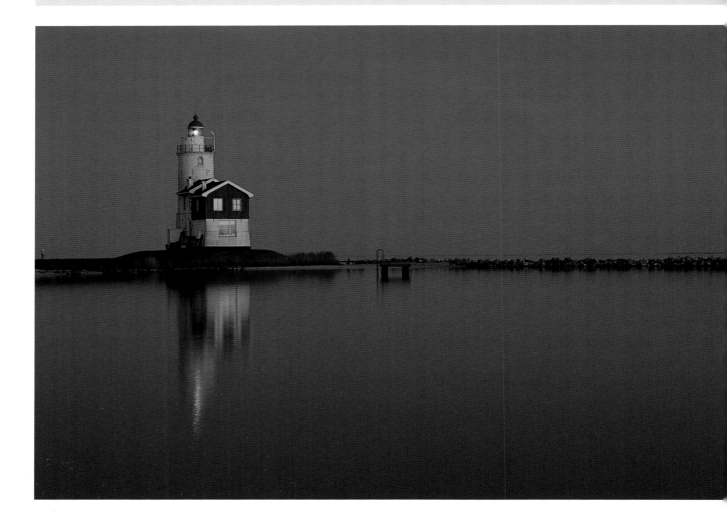

as close to your subject as you can, and making that last shot while on your belly, turn over onto your back and take just one more shot while shooting straight up.

While walking on your knees, you no doubt discovered a far more intimate portrait of the small child or perhaps recorded a far more intimate "portrait" of the barn that had the added drama of depth and perspective since the golden wheat that surrounds it now fills up the foreground of the image. Perhaps also, while on your belly, you discovered a wonderful and fresh composition of the surrounding park framed through the feet and lower legs of your friend or spouse. And, most of all, you learned the inherent vision, when combined with differing points of view, of your 28mm or 35mm focal length lens.

But, you've only just begun! Make a point to do the same exercises at 50mm, 60mm, 70mm, 80mm, 90mm, and 105mm. If you maintain this regimen of "eye exercises" once a week for three months, you'll have a vision that is shared by fewer than 10 percent of all photographers, and it will be a vision that gets noticed. At that next on-location photography workshop, you won't be in that group of students wandering around uncertain about what lens to use. Once you've integrated the vision of your lenses into your mind's eye, you can stand at the edge of a meadow or lake and scan the entire scene, picking out a host of compositions even before you place the camera and lens to your eye.

It is my belief and strong conviction that any creative endeavor—including learning to see creatively—*cannot* begin as long as you are feeling anxious and lost. Understanding the unique vision of your lenses and differing points of view will set you on a journey of unlimited possibilities!

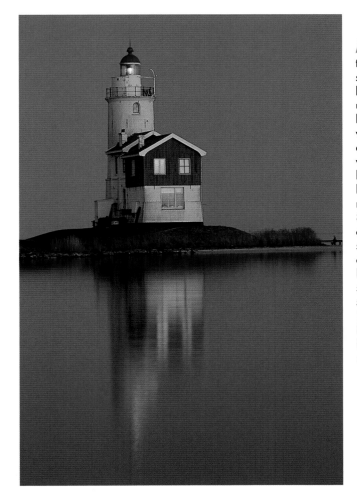

As the sun neared the horizon to the west behind me, I moved off the jetty and over to the left, staying on the nearby shoreline. Since the Iselmeer was unusually calm this day, I knew a mirrored reflection would be present. What I didn't know was that the sun was also reflecting in the lighthouse windows. I quickly set up my tripod and mounted the camera and a 80–200mm lens. My first compositional choice was to set the focal length to 80mm and compose this pleasing horizontal (opposite). To add some additional color to the scene, I placed an FLW filter (not to be confused with the FLD) on the lens. (The FLW, like the FLD, imparts a magenta color, but the FLW is a deeper shade of magenta.) With my aperture set to f/11, I then adjusted the shutter speed for a 1/15 sec. exposure and fired off several frames.

Another opportunity to shoot a vertical composition lay right before me. After loosening the tripod collar, I spun the camera and lens to the vertical position, and then zoomed out to 180mm and framed a much tighter composition of just the lighthouse and its reflection (left). With the aperture set to f/22, I adjusted the shutter speed until 1/4 sec. indicated a correct exposure.

[Opposite: 80–200mm lens at 80mm, 1/15 sec. at f/11. Left: 80–200mm lens at 180mm, 1/4 sec. at f/22]

Wide-Angle Lenses

Every picture made with *any* given lens is capable of telling a story, but as most serious landscape photographers have discovered and know quite well, there's no better lens for storytelling—storytelling with exacting sharpness from beginning to end—than the wide-angle lens. Although the 35mm and 28mm are considered members of the wide-angle family, the better stories are most often told with these much wider focal lengths: 24mm to 15mm, and sometimes even the fisheye (see page 24).

According to the famous phrase, "Every picture is worth a thousand words," and if your goal is to create compositions that invite a thousand-word response, then these are the lenses that can do it. There are several reasons for this. One is their great angle of view: from 84 degrees (with the 24mm) all the way to a whopping 111 degrees (with the 15mm). The other reason is their incredible depth of field. For example, when a 28mm lens is set to *f*/22, the maximum depth of field (the total area of sharpness from back to front in an image) is roughly three feet to infinity, but when a 20mm lens is set to *f*/22, the maximum depth of field is roughly eighteen inches to infinity. That's eighteen inches *closer* to the foreground flowers, eighteen inches closer to the edge of the stream, eighteen inches closer

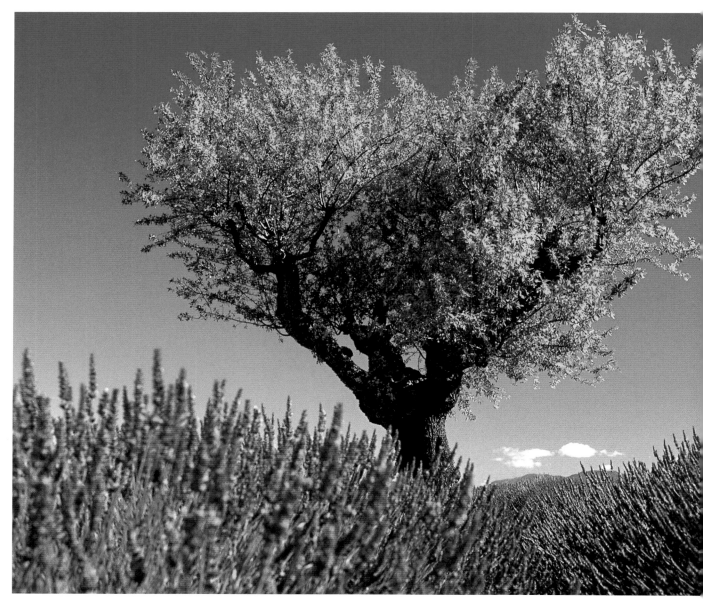

to the foreground rocks, and eighteen inches closer to the tree bark. These wide-angle lenses, more than any others, are capable of creating some very up-close-and-personal moments.

Unfortunately, very-wide-angle lenses continue to get a bad rap from some amateurs because these lenses make creating good composition more challenging. The most common complaint—"It just makes everything small and distant, and it gets *way* too much stuff in the picture"—is precisely the reason why these lenses are my personal choice for most of my landscape work. I love the scope of material that wide-angle focal lengths bring inside the frame. All that "stuff" provides fertile ground for selecting subjects to manipulate and emphasize. The trick is to pay attention to your point of view and, subsequently, to pay close attention to what's going on inside the viewfinder.

In addition to its much greater and sweeping angle of view, the wide angle increases the sense of distance from foreground to background. This wonderful illusion of depth and perspective can serve as the "hook" that results in the viewer's immediate participation when a foreground subject is utilized. Noted photographers such as Ansel Adams, David Muench, Carr Clifton, Pat Ohara, and John Shaw, to name just a few, have used their wide-angle lenses to make some truly emotion-filled storytelling imagery. Almost always without fail, their images have viewpoints that encompass immediate foreground interest: the bark of a tree framing a distant farmhouse, the round stones at the edge of a lake, or the vivid blooms in a wildflower meadow at the base of distant mountains.

Compositions of this type will always evoke powerful emotional responses from viewers, whose senses of

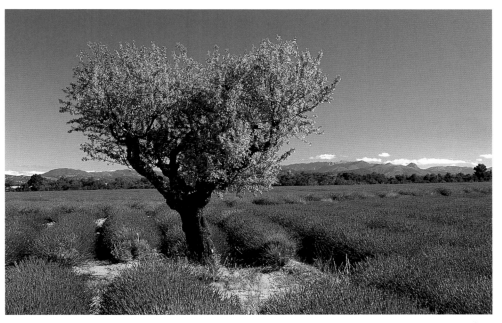

While living in France, I have been fortunate to make three annual summer journeys to the Valensole Plain in southern Provence, and I still have yet to even come close to capturing all of its boundless beauty. The Plain attracts many visitors from all parts of the world, many of whom, not surprisingly, come equipped with their cameras. What is equally *not* surprising is that most of them stand at the edge of the many rows of lavender and frame compositions that are seldom inviting. A classic example of this is

the image above, which I shot holding my 17–35mm lens set to 20mm. As so many have done before me, I stood at eye level, and framed some rows of lavender and a tree with the surrounding hills far off in the distance. It's a nice photograph, but it does little to invoke the viewer's sense of participation. By simply getting down low and shooting from the honeybee's point of view (left), I awaken the viewer's sense of smell and touch. Additionally, this image has a cleaner and more graphic composition.

Note the deliberate inclusion of the lone cloud on the horizon and how it helps to impart an even greater sense of distance from front to back. To get this, I had my camera and 17–35mm lens on a tripod, the focal length again at 20mm, and my aperture set to f/16. I then preset the focus via the distance setting and simply adjusted the shutter speed until 1/125 sec. indicated a correct exposure.

[Above: 17–35mm lens at 20mm. Left: 17–35mm lens at 20mm, 1/125 sec. at f/16]

smell, touch, and sometimes even taste are awakened. Oftentimes, all that's required of you is to place yourself in that wildflower meadow and be willing to change your point of view.

In addition to your willingness to get down low in a meadow to create emotion-filled, storytelling compositions don't forget the literally thousands of other landscapes. All it takes is a little imagination and one very simple question: What does the world look like when viewed through the "eyes" of fresh strawberries on the vine, or a child's crushed glasses at the local playground, or a lost pacifier at the local shopping mall, or the dead owl along the interstate, or a flat tire in the Nevada desert, or a rake gathering autumn-colored leaves, or a starfish clinging to the rocks at low tide? It's time to grab those worn-out dungarees—you're going to begin spending a lot of time on your knees and/or belly.

What does the world look like through the eyes of one of the local tomcats on the small Italian island of Burano near Venice? In order to answer this question, I chose to meet the cat at its eye level, and that could only mean one thing: lying on my belly. Do I ever feel intimidated at the prospect of dropping to my knees or stomach to get the shot? Absolutely I do, but only when I have an "audience"—like the two elderly couples on their front porches fifteen feet behind me while making this shot. They had certainly noticed the stranger with the camera gear, and I, in turn, felt some overwhelming shyness.

As I often do at times like this, I simply ask myself, "Am I going to put a potentially compelling image on film, or am I going to just walk away because a few people appear to be watching my every move?" Obviously, I made the decision to face my fears as I most often do, and with a pair of steady elbows, I handheld my camera and Nikkor 17–35mm wide-angle lens, using a focal length of 17mm. I then chose an aperture of f/16, preset my depth of field via the distance setting, adjusted my shutter speed until 1/60 sec. indicated a correct exposure, and proceeded to shoot several frames. Although I speak no Italian, I'm quite sure that a conversation was taking place behind me about the man with the camera lying down in front of a cat.

Facing your fears head-on will definitely improve your ratio of success tenfold if not more. On those few occasions when I didn't face my fears and take the shot, my ability to "see" was, for the remainder of the day, clouded by a sense of loss about not taking that really great shot of. . . . So, are you ready for the ultimate challenge of facing your fears head-on? Get on your belly, and show the world how Manhattan looks from the sidewalk's point of view— preferably at noon! Fear of looking "foolish" to those around you should never be a reason for not creating a compelling image.

[17–35mm lens at 17mm, 1/60 sec. at f/16]

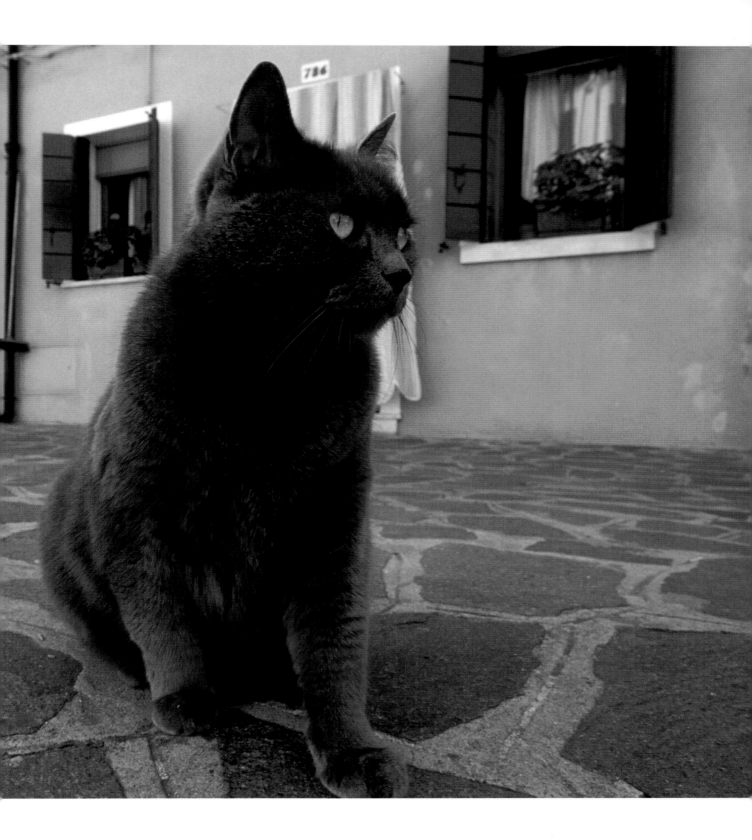

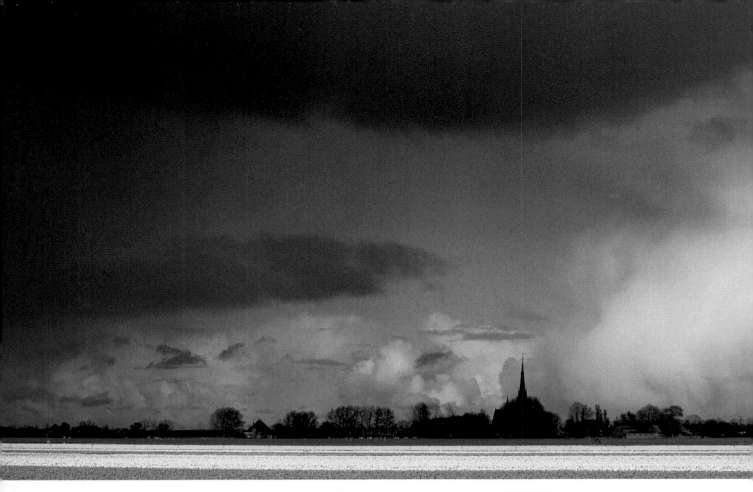

A fierce battle takes place every April in Holland as spring attempts to wrestle itself from winter. Hailstorms, heavy winds, and rain are not at all uncommon. Ask most Dutch people about the changing seasons and they say they find it "oh so very cozy." I found this compelling composition—also created with the lens "that makes everything small and distant"—when presented with those dramatic storm skies. Rather than filling the foreground with "stuff" I filled the *background* with stuff. And, true to its reputation, the wide-angle lens did make the landscape small and distant, but thanks to its wide and sweeping vision, I was able to fill up the frame with the strength and power of a fast approaching hailstorm, plus include a bit of the field of blooming tulips.

[20mm lens, 1/500 sec. at f/8]

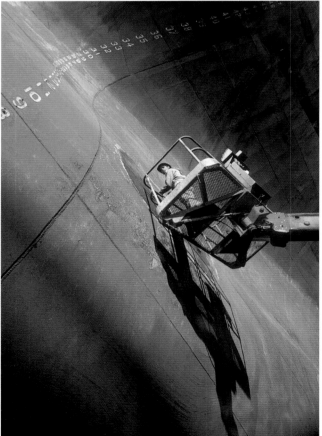

Over time, every photographer can describe one if not several "defining moments." These are best thought of as turning points or revelations in your pursuit of photographic excellence. Some years ago, I was shooting in the shipyards of Portland, Oregon. Of the many compositions I made over the course of the two-day shoot, none was more defining than this one of a worker who was preparing the ship for painting. Up to this point I had done my share of looking up through stands of trees in the woods but had never used this viewpoint in an industrial setting. Note that I didn't use a tripod; I just held the camera and looked up.

[20mm lens, 1/60 sec. at f/8]

I was determined to create a composition through the "eyes" of well-worn cowboy boots and quickly discovered the shot I'd envisioned—boots framing the distant roping of calves. This "frame within a frame" composition *always* creates a feeling of depth and perspective, especially when made with the wide-angle lens. Supporting my camera on a pair of steady elbows, I chose an aperture of f/22, and preset the depth of field via the depth-of-field scale. I then adjusted the shutter speed to 1/60 sec.

Can you imagine the fresh and exciting visuals you would record if you spent the next year on your belly looking through other people's feet? The muddy boots of a construction worker at a construction site. The bare feet of a child at the ocean's edge. The hiking boots of a mountain climber ascending to the mountain top. The black, shiny wing tips of the stockbroker on Wall Street.

[20mm lens, 1/60 sec. at f/22]

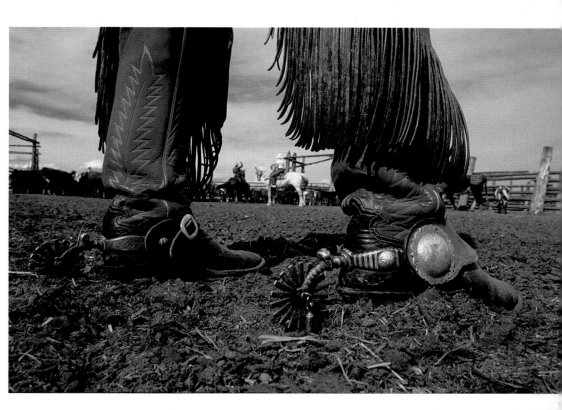

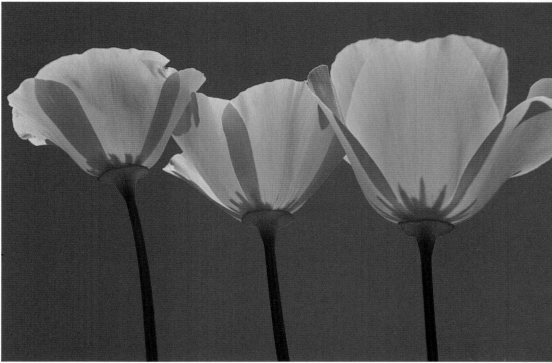

When you tire of lying on your belly, consider looking up with your wide-angle lens. If you choose the right subjects, you'll bring your audience right into the image. When I saw these poppies in a roadside ditch, I tried to isolate and shoot a small group of them at flower level with my 300mm lens and one extension tube. No matter what I tried, I couldn't get a clean composition. It wasn't until I switched to my 17–35mm lens—with the idea of looking up—that I found a view that was not only clean but quite graphic. Lying flat on my back with my focal length at 17mm, I was able to compose three blooms against a clear blue sky.

[17–35mm lens at 17mm, 1/125 sec. at f/16]

The Full-Frame Fish-Eye Lens

The "full-frame" fish-eye lens, one of the widest of all the wide-angle lenses, is the ideal lens for photographers who can never seem to keep their horizon lines straight! Most fish-eye lenses will naturally "bend" the horizon line with the slightest tilt of the camera. The full-frame fish-eye lens incorporates an extremely wide angle of view—upward of 180 degrees—and it can also focus extremely close.

Off the coast of Melbourne, Australia, I found myself harnessed to the open door of a helicopter with my legs and feet resting on the skids, hovering about 100 feet above this oil tanker. I was on assignment for one of the world's largest petroleum producers, and the theme of this particular campaign was to convey the company's worldwide presence. A wide open ocean, the lone tanker, and my fish-eye lens all combined for a composition that successfully conveyed this idea—"covering the globe." With my camera and Nikkor full-frame 14mm fish-eye, I set the aperture to f/8 and adjusted the shutter speed to 1/500 sec. To avoid recording the helicopter's blades overhead, I asked the pilot to "pitch" the helicopter so that it was angling away from the ocean, and I then stood out on the skid and leaned over in the opposite direction while shooting down.

[14mm lens, 1/500 sec. at f/8]

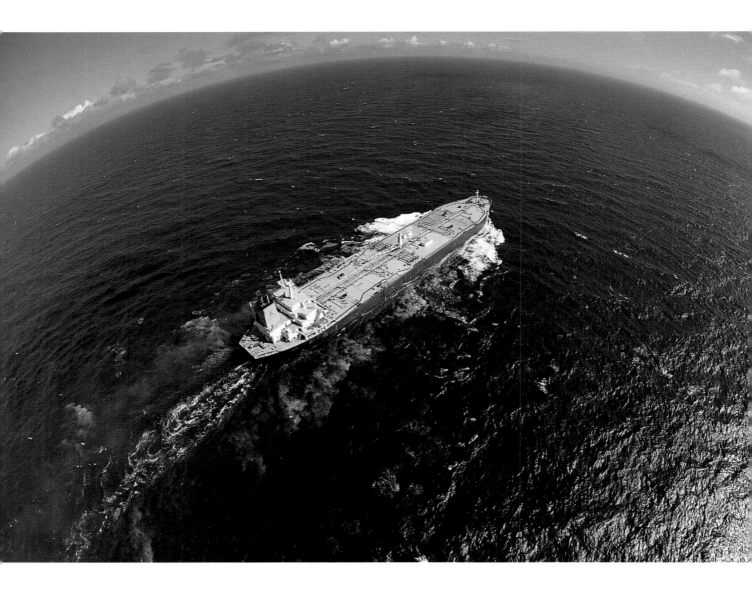

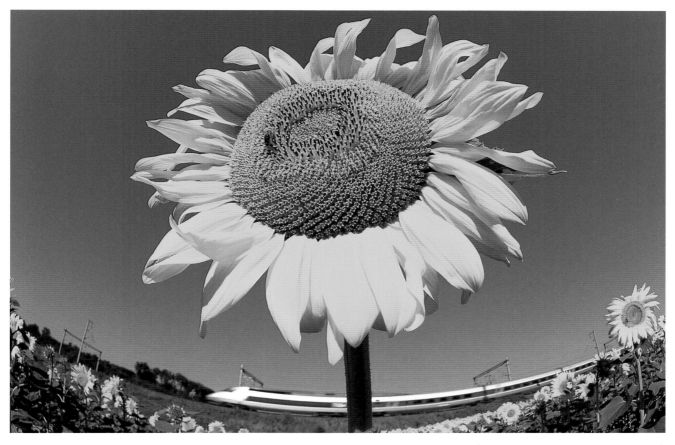

Throughout much of Europe, high-speed trains are the most common mode of transportation between major cities and countries. Many of these trains pass through some picturesque countryside, and particularly in late June, numerous sunflower fields fill the countryside. I found the perfect sunflower and chose a composition that would also include one of the trains in the background. With my camera and Nikkor full-frame 14mm fish-eye lens mounted on a tripod, I didn't have to wait long for the train to come through the scene, as this particular track is used quite frequently. In addition, I was fortunate to have a honeybee pollinating the sunflower at the same time the train passed through.

[14mm lens, 1/500 sec. at f/8]

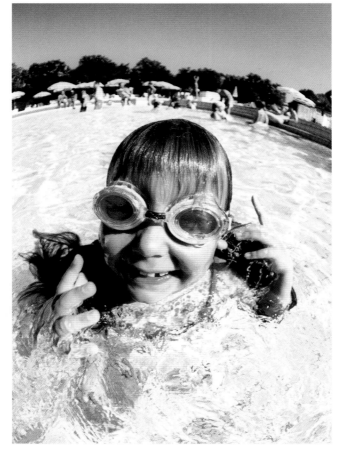

Since most photographers wouldn't normally reach for the wide-angle lens to shoot portraits, many assume you'd have to be "nuts and ill-informed" to choose that lens. Not so! Learning to see has every bit as much to do with integrating the vision of your lenses as it does with falling *out* of line, or what Thoreau called "listening to the sound of a different drummer." A little experimentation here and there is good for the soul, as it often can lead to exciting discoveries. The joy on the face of my daughter Chloe at the pool was best conveyed by the full-frame fish-eye. It's a fun composition, and the fun distortion caused by the extreme angle only serves to emphasize the joy of summer. No tripod was necessary; I simply held the camera at the water's edge and took the shot.

[14mm lens, 1/250 sec. at f/8]

Street Zooms

Is there such a thing as the all-purpose lens? Perhaps not in a single focal length, but with the recent proliferation of compact and amazingly sharp zoom lenses, there just might be the all-purpose *zoom* lens. Whether your choice is the 28–105mm, 28–80mm, 28–70mm, 35–105mm, or my personal favorite, the 35–70mm, a wealth of compelling imagery is possible. These "street zooms," as I call them, are appropriate when you're heading out the door for a walk in the city or countryside; they're not noted for exaggerating perspective or for compressing backgrounds but rather, simply, for recording "real life." In addition, most if not all of the street zooms offer a macro or close-focus feature, and this added bonus has allowed me to record some truly compelling imagery, as well. I've been asked on more than one occasion which one lens I could *not* live without. My answer is always the same. It's my well-worn Nikkor 35–70mm F2.8.

In reviewing my work over the past ten years, it's quite apparent that this one lens has accounted for more than 75 percent of my work! This might seem quite shocking to some, considering that many photographers are led to believe that to create truly successful imagery one must spend hundreds, if not thousands, of dollars on the widest of the wide-angle and perhaps even more on several telephoto lenses. And, as I've often heard, both from students enrolled in my Internet photography courses and in my on-location workshops, the street zooms "are far too limiting."

I could not disagree more. I do agree that a focal length of 28mm or 35mm can make you wish for a wider angle of view at times, especially when you are photographing building interiors or landscapes. And, I also agree that when photographing a coastal sunset at the 70mm, 80mm, or 105mm focal length, it is impossible to record that big ball of orange setting behind the distant sailboat. However, these two particular examples are but a small fraction of the photographic opportunities that exist in the world around us. A friend at Kodak recently informed me that the biggest reason most photographers purchase a camera is to record images of their family, friends, holidays, and vacations—and I know of no better lenses for just this purpose than the street zooms.

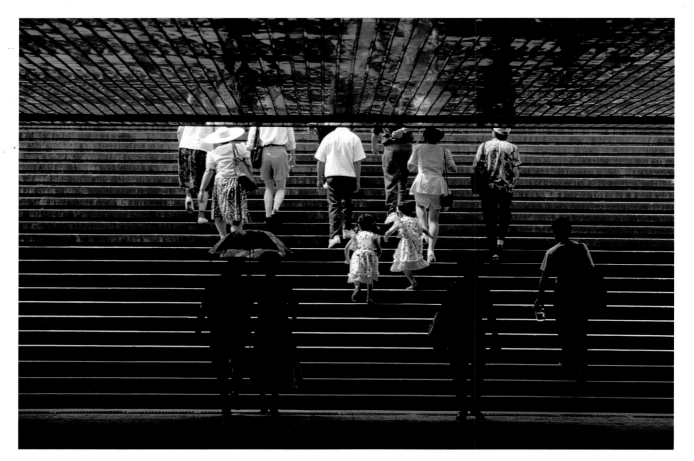

In 1993, I was invited by the Chinese government to come to Beijing and spend ten days photographing the city and its people in an effort to help them win their bid for hosting the 2000 Summer Olympics. Although their bid was not successful, I had a great deal of photographic success. I was living a photographer's dream as I was provided with a chauffeur-driven Mercedes Benz and two Chinese assistants, both fluent in English and both having tremendous influence over the Chinese people I photographed.

On one such occasion, I stopped to make a photograph of a group of people ascending the stairway in the tunnel between The Forbidden City and Tiannamen Square (opposite). While composing this image, two little "girls" in the frame—in brightly colored dresses—caught my eye, and I told one of my assistants that I would love to get a shot of them both in the square. The words had barely left my lips when, as I climbed the stairs a few minutes later, they were there waiting for me, along with their parents. Kneeling from six feet away and zooming my 35–70mm lens to 70mm, I was able to fill the frame with the two children.

After firing off several frames, I asked (as I always do) for a *model release.* I also learned—as I had suspicions—that the child on the left was, in fact, a boy. He loved his twin sister's dress so much that, following much insistence, his mother purchased one for him, as well. Now that's what I call a mother's love!

[Opposite: 80–200mm lens, 1/250 sec. at f/8. This page: 35–70mm lens at 70mm, 1/250 sec. at f/5.6]

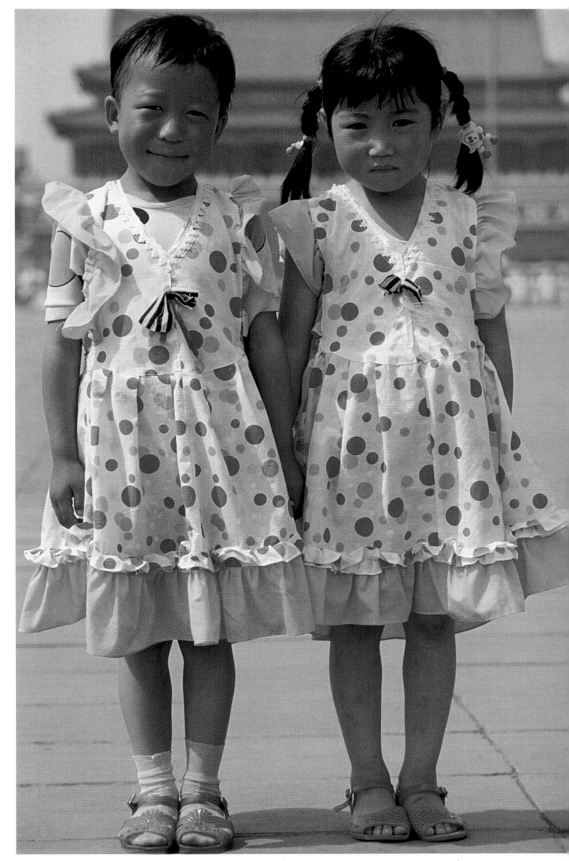

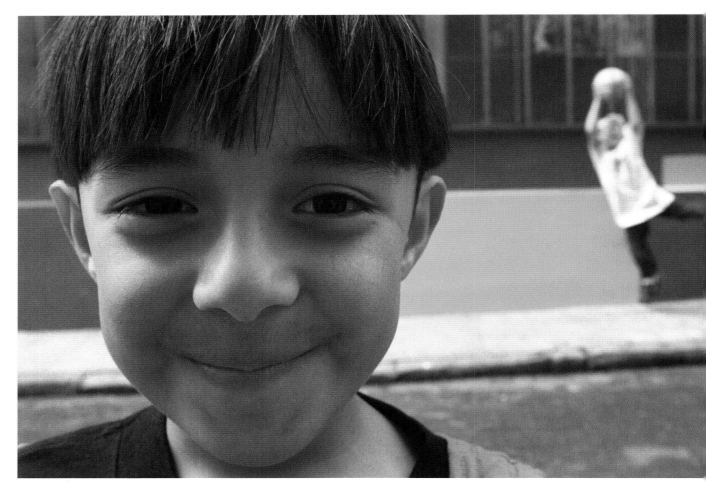

Shooting environmental portraits is best done with the street zooms. My definition of an *environmental portrait* is an image in which both the subject and a portion of the surrounding environment are included and defined. In particular, I favor the 35mm and 50mm focal lengths. They are the ideal choices for getting in close without causing facial distortion, and they both do a good job of rendering just enough of the surrounding environment.

On an assignment for Kodak, I had the opportunity to shoot a number of city kids playing soccer in an alleyway. While composing the portrait of one boy, another young boy was busy leaping repeatedly as several other boys kept kicking soccer balls his way. With my camera and Nikkor 35–70mm lens on a tripod, I was assured of recording a composition in which the bulk of the frame was filled with a portrait while the boy leaping in the background made a whimsical addition. If you take your hand and cover up the leaping boy, this image immediately appears flat and ho-hum. It's fair to say that without the added environment, this picture would not succeed.

[35–70mm lens at 35mm, 1/250 sec. at f/11, Kodak Max 800 (which accounts for the higher shutter speed with this aperture)]

During a lunch break while on assignment at a steel mill in southern Ukraine, I asked one of the cleaning ladies if she would pose for the camera. She, unlike most of the other mill employees, had no trouble at all smiling, and perhaps that was part of my motivation in asking to take her picture.

While holding my camera, it seemed natural to place her in the middle of an otherwise desolate factory landscape. Alone among her depressing surroundings, she still manages a smile—I love the human spirit! Before thanking her and getting a signed release, I also made a point to walk closer to her, changing the focal length ever so slightly and placing her a bit off center in the composition. And without fail, she continued to smile as I fired off several more frames (opposite).

[Both photos: 35–70mm lens, 1/60 sec. at f/11]

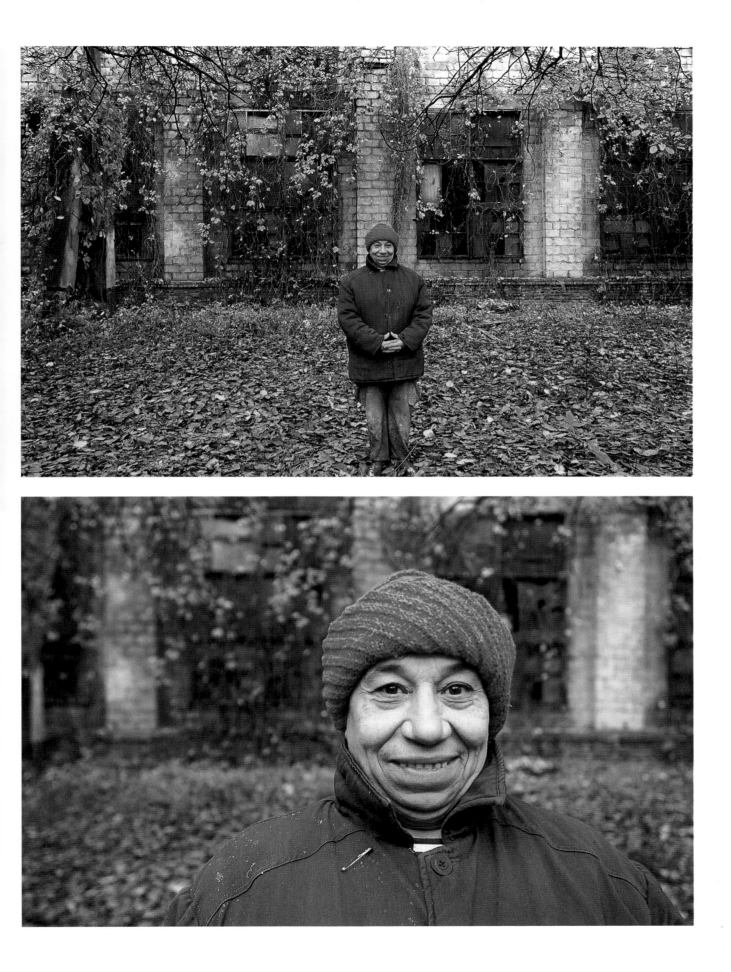

It has always been my goal and subsequent style to, whenever possible, record compositions that are clean and simple, yet graphic and filled with color. In the summer of 1997, following the construction of our backyard swimming pool, I was hired by Kodak to shoot a series of images for an upcoming trade show, as well as for use in camera stores. Of the many images I made over the course of seven days, this one remains one of my favorites, and it was also featured in *Communication Arts* Photography Annual 2001.

As a result of so many prior experiences climbing stairs, trees, and ladders and then shooting looking downward, I knew that the cleanest and most graphic composition of the ball and fins would result from shooting from a high viewpoint. Atop a twelve-foot stepladder at the edge of the pool, I asked my subject to take one step into the pool and my assistant to float the ball into position. A few seconds later, with minimal disturbance to the water, I got this composition while handholding my camera and Nikkor 35–70mm lens set to the 70mm focal length. With my aperture set to *f*/11, I simply adjusted the shutter speed until 1/125 sec. indicated a correct exposure.

[35–70mm lens at 70mm, 1/125 sec. at *f*/11]

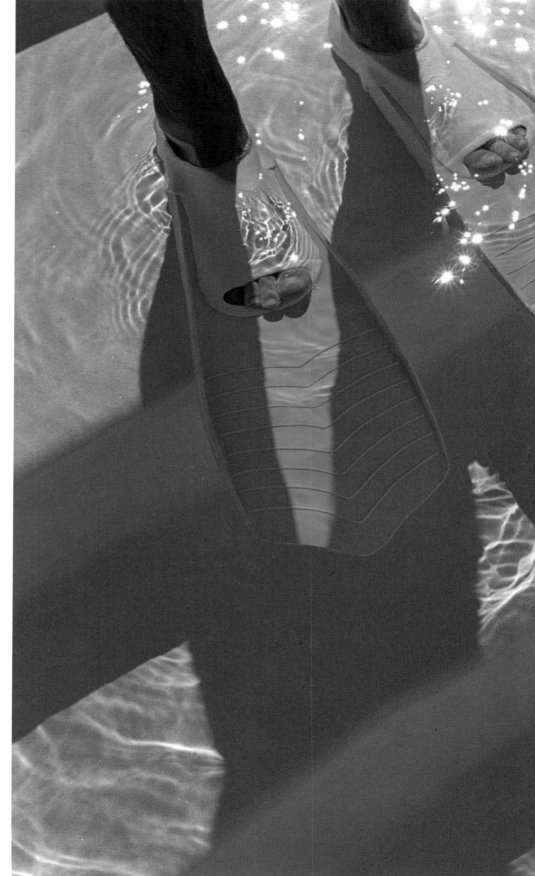

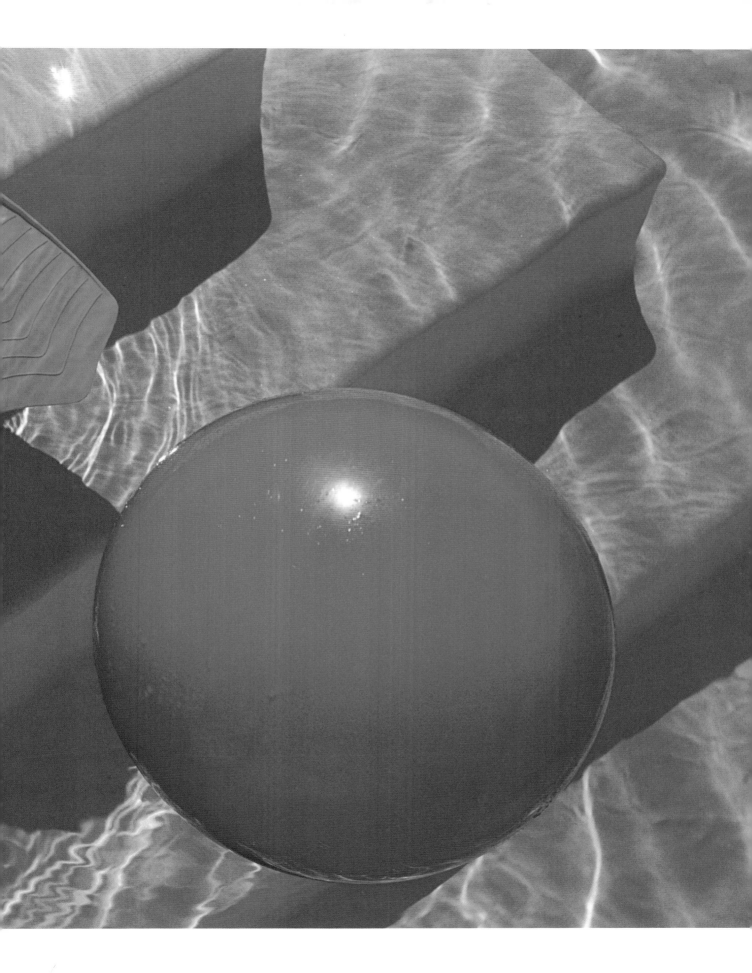

If you have yet to discover the close-focus feature that comes with most of the street zooms, you shouldn't waste a minute in getting out the lens now and taking a look. If you can use your macro or close-focus feature at the 28mm or 35mm end of the focal-length range, you're about to discover another vision that will add up to even more compelling imagery. This pair of photos is a good example of this.

During the first few weeks of August, the Mount Adams wilderness area in Washington State is a wildflower lover's paradise. One part, called Bird Creek meadows, continues to be one of my favorite spots. While standing there with my camera and 35–70mm Nikkor lens, I recorded an ordinary composition (left) that, predictably, garners only an ordinary "ho-hum" response. So, how do you turn the ordinary into the extraordinary? More often than not, a simple change in your point of view will do the trick. With my Nikkor 35–70mm, the macro/close-focus feature is activated when shooting only at the 35mm focal length. The wonderful thing about this feature, however, is that I can shoot macro/close-up shots and still maintain the moderately wide-angle view of the 35mm lens—a view that I call upon time and time again for effective and powerful storytelling.

Lying on my belly and with the camera and 35–70mm Nikkor lens up to my eye, I had already set the focal length to 35mm (where the close-focus feature is found on my lens). I focused on a small group of Indian paintbrush and, with my aperture set to f/22, depressed the depth-of-field button and confirmed that Mount Adams would in fact record on film as an out-of-focus but very definable element in the composition. I could have composed a frame of only Indian paintbrush, but that would have hardly made sense since I wanted to show a sense of place (the alpine meadow) and that the Indian paintbrush shares the ground with other flowers and trees.

Although I would have also enjoyed rendering this same composition in exacting sharpness from flowers to distant mountain, there isn't a 35mm camera/lens combination that would allow it. The solution for recording exacting sharpness from such a close foreground through to infinity is to use a 4x5 view camera.

[Both photos: 35–70mm lens at 35mm]

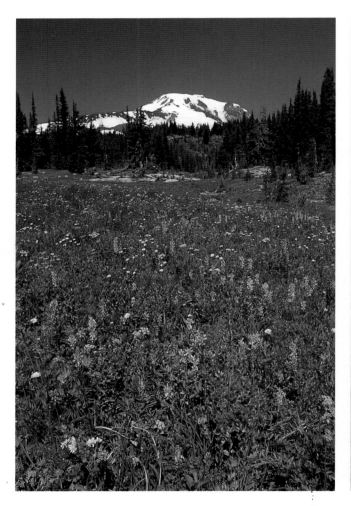

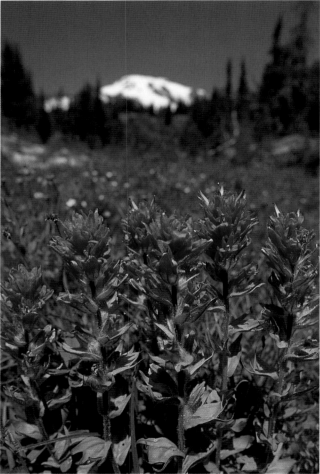

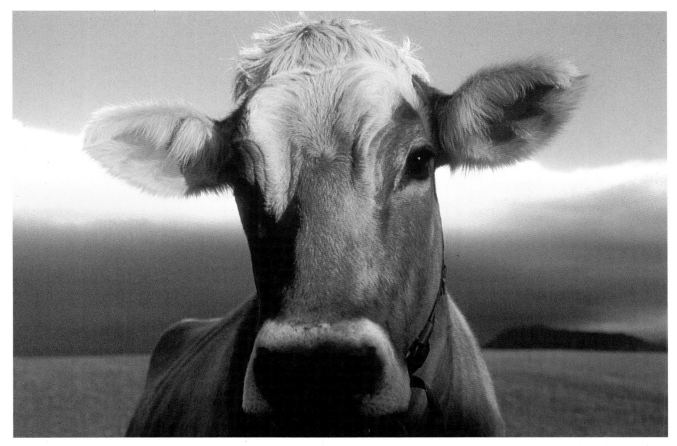

One Saturday afternoon during the early '90s when I was living in Germany, I was heading out the door to do my weekly grocery shopping when I reminded myself to bring my camera and Nikkor 35–70mm lens. I don't know about your own experiences, but I'm in the habit of always taking at least my camera and 35–70mm lens with me wherever I go—even on those days when I'm really not looking to take pictures. This has enabled me to snag a few prizewinners now and then, and this picture is one of them. It was later featured in a national advertising campaign promoting a new video game by Nintendo and in *Communication Arts* Photography Annual 1993.

Throughout the day that I made this image, southern Bavaria had been experiencing thunderstorms. As I was returning home from the gro-cery store, a rather large window of light opened up to the west. At about the same time, I was passing a rural landscape with lots of green pastures and one lone cow. I quickly pulled over, knowing that the cows of Bavaria are naturally curious and this one would, in all likelihood, approach me as I stood in front of the fence that surrounded the field. My hunch was correct, and as the cow got closer, the light just kept getting better and better. With a focal length of 35mm, I patiently waited for the cow to fill the frame and wasted no time in firing off just two frames! I was out of film! I had failed to check the film counter on my camera before leaving the house. Had I done so at that time, I would have put in a fresh roll.

[35–70mm lens, 1/125 sec. at f/11]

What If. . . ?

Once you begin making discoveries about how your lenses see, don't be surprised if you find yourself at times consumed by the question "What if. . . ?" What if you focus close on your toaster and, as the blue smoke rises from inside, invite your wife—with the baby in her arms—to run toward it? What if you focus on a passport lying on the sidewalk and include a businessman getting into a taxi in the background? What if you focus on a bottle of sleeping pills with a woman asleep in her bed in the background? What if you focus close on a broken window-pane with a solemn-looking little boy, glove and bat in hand, in the background? What if you focus on part of the hand and thumb of a hitchhiker on a busy interstate? What if you focus close on a used syringe in an alleyway? What if you focused close. . . ?

The Telephoto Lens

Our desire to see objects up close is innate. Prehistoric man no doubt wished he could have seen the saber-toothed tiger up on the knoll before it was too late. Along came the telescope and sailors were able to steer clear of approaching pirate ships. And it wouldn't be much longer, with the invention of binoculars, before all of us could go to a football or soccer game and put ourselves down on the field with the action. Like telescopes and binoculars, telephoto lenses offer a safe haven for viewing the world around us.

Standing along the shoreline with a telephoto lens you can observe migrating whales, and feel their power and presence without having to jump in the water next to them. You can get into the nest with the robin and her babies with nary a worry of disturbing the brood. You can reach a building engulfed in flames without

Great subjects and viewpoints alone (this one in Nesselwang, Germany) don't guarantee the best possible photographic compositions. Make sure you use the right lens for the subject. The image made with the wide-angle lens (left) is not as successful as the one made with the telephoto (right). That one focuses your attention immediately on the steeple and the mountain range.

With my Nikkor 300mm lens and camera mounted on a tripod, I was able to "cut to the chase" and frame the mighty and proud steeple against the backdrop of the German Alps. I chose an aperture of f/32 to assure that I got a maximum depth of field in the image.

[Left: 35–70mm lens at 35mm, 1/125 sec. at f/16. Right: 300mm lens, 1/30 sec. at f/32]

having the slightest concern about your own personal safety. It is the telephoto lens that truly can take us places we may never otherwise visit—for example, the craters on the moon. It is, for many photographers, a lens of great adventure.

In addition to the telephoto lens' ability to make big images of distant and sometimes inaccessible objects, it's just as important to note its narrow angle of view. This contributes to its ability to cut through visual clutter and make a subject "shout" at the viewer. If the wide-angle is the storytelling lens, then the telephoto is the exclamation point at the end of the sentence, rendering details with eye-stopping clarity. Telephoto lenses are available from the very moderate 70mm to the extremely large and heavy 2000mm. Although single-focal-length telephotos, such as the 105mm and 300mm, were once the choice of the discriminating shooter, the telephoto zoom, or tele-zoom, has gained tremendous popularity.

Ten years ago, the telephoto zoom was looked upon by many with a suspicious eye—great idea but couldn't possibly deliver the sharpness or contrast required by demanding photographers. Today, due to numerous advances in technology and design, the telephoto zoom has become the standard for demanding professionals, as well as the norm for most every amateur photographer. Aside from the SLR (single-lens-reflex) digital

With my camera and 80–400mm lens on a tripod, I chose a distant viewpoint and set the lens to 80mm. Although it's an okay shot (top), it falls short of capturing the grandeur of the landscape behind the subject, my friend Bruce. It does show the weather overhead, but if my aim had been only to showcase Bruce against a wide open sky, I wouldn't have needed a mountain to do it. I could just as easily have taken him to the local park and lain on my stomach near his feet, shooting upward with a super-wide-angle lens against a backlit sky. It wasn't until I changed my focal length to the 300mm range, that I got the effect I was seeking of Bruce alone on the mountaintop against rolling hills. An aperture of f/32 assured maximum depth of field.

[Top: 80–400mm lens at 80mm. Bottom: 80–400mm lens at 300mm, 1/60 sec. at f/32]

cameras, all other digital cameras are equipped with a fixed and permanent zoom lens, most often including the telephoto range in the zoom's design. This standard equipment is affirmation once again of man's desire to see far objects up close. Rare is the digital camera that offers a super-wide-angle lens as part of its entire zoom range. Also, until recently, most telephoto zooms were either 70–210mm or 80–200mm. Although tele-zooms in this range are still manufactured and purchased, quite a number of photographers are opting for the even lighter and longer tele-zooms: 60–300mm, 80–400mm, and even 100–500mm. Several of these lenses even offer a vibration-reduction feature that lets you shoot images at shutter speeds normally considered too slow for hand-holding, i.e. 1/60 and 1/30 sec. I recently purchased an 80–400mm with this feature, and it really works. But for me, old habits die hard, so more often than not, I still mount the camera and this lens on a tripod.

As is probably apparent by now, I believe in using a tripod a great deal of the time. As a general rule, I do not believe it is a good idea to use any camera and lens combination off of a tripod when the shutter speed falls below the focal length of the lens. For example, if you are using a tele-zoom with a maximum telephoto range of 300mm, I would suggest not shooting without the tripod at shutter speeds below 1/250 sec. (This same rule would apply even if you are using the 60mm focal length range of your 60–300mm tele-zoom, since the overall weight of the lens hasn't changed.) If you're not using a tripod when you are photographing, then certainly you could use a monopod when the shutter speed falls below the recommended range for handholding the camera. In addition to obtaining razor sharp images, the tripod is also vital for learning the art of composition. (See pages 86–127 for more on composition.)

As I mentioned earlier, the telephoto lens has a natural tendency to reduce depth of field and compress space, as well as reduce backgrounds and foregrounds to muted tones of color and/or shapes. When I saw this elderly man in a small village in the Alsace region of France, it was an immediate no-brainer. Overflowing boxes of flowers surrounded him on both sides. "What a great background!" I exclaimed to myself and to the two students who were with me at the time. His warm and friendly smile was an obvious invitation for conversation, and I soon learned he was a local woodcarver and had lived in this small village his whole life. Being asked to pose was, in his words, "a treat," and my two students and I wasted no time in taking his picture.

Although the first photograph is a good example of a simple and pleasing environmental portrait, it doesn't come close to capturing the warmth of his smile or the texture of his face. So, I asked him to stand no less than ten feet in front of the flowering window boxes. Then, with my camera and 80–200mm mounted on my tripod, I set the focal length to 200mm and the aperture to f/5.6. This combination of distance between subject and background plus the large lens opening assured me of recording a razor-sharp image of the subject against a harmonious wash of blurry background tone and color.

[Left: 80–200mm lens, 1/125 sec. at f/8. Above: 80–200mm lens at 200mm, 1/250 sec. at f/5.6]

Following the sprinkling of several packets of seed in my own backyard "meadow," my three-month wait was over. Flowers were everywhere, and I wasted no time over the course of several days shooting numerous lone-flower compositions. With my 300mm lens, 36mm extension tube, and camera on a tripod, I came upon this lone Shirley poppy and made sure to place it against a small area of green, which in this case was nothing more than the stems of flowers in the background. Paying further attention allowed me to showcase the flower's color against background tones of reds, pinks, and purples (also due to the background flowers).

I know of no better combination of equipment to achieve this type of lone-flower-against-supportive-background composition than a 200mm or 300mm lens with the addition of a large extension tube. The extension tube will more than likely be necessary *even if* your tele-zoom offers a macro or close-focus feature. The addition of the extension tube simply allows your lens to focus even closer and also reduces the area of sharpness (the depth of field) even further. This is vital since in most gardens, meadows, and fields the flowers often grow quite close together. *Note:* Don't confuse extension tubes with a doubler, or what is also called a 2X converter. An extension tube is simply a glassless metal tube (normally sold in sets of three) that, when placed between the lens and the camera, extends your close-focusing range. You won't be able to focus the lens to infinity again until you remove the tube, but when it comes to doing the selective-focus close-up work, who cares about infinity?

[300mm lens, 36mm extension tube, 1/250 sec. at *f*/5.6]

This lone pigeon caught my attention as I approached a fountain in the early morning while walking the streets of Rothenburg, Germany. As I already had my camera and 80–400mm lens on a monopod, I was quick to set up, and from a distance of about twenty feet and focal length set to 400mm, I was able to "pull" the bird out of a background that was comprised of a large hotel wall with numerous windows. In addition to the long focal length, my subsequent aperture choice of f/8 also helped in rendering the background as muted tones and shapes.

[80–400mm lens at 400mm, 1/60 sec. at f/8]

Manuel is the three-year-old son of my friend Arnold. He has one of those faces that makes you run for the camera. With any children, you absolutely must compose the shot at their eye level if you want to convey their sense of innocence. I asked Manuel to get on his belly about twenty feet in front of a large evergreen hedge. I followed suit, meeting him at his eye level, and was able to record the background hedge as a washed-out tone of green, which served as a nice backdrop.

[300mm lens, 1/500 sec. at f/4]

It's so "French" to go to the bakery every morning and buy your baguette. It's not uncommon to see the café, bistro, and restaurant owners carrying armloads of baguettes out of the bakeries and onto the streets as they head back to their own places of business. On one such morning, my wife was going off to buy some baguettes for an upcoming get-together with friends. I immediately thought, "Photo-op!"—and as she headed out the door, we agreed to meet near the bakery after she made her purchase and I went to gather up my gear. With my Nikkor 80–400mm lens and camera mounted on a tripod, I was able to compress the space in the background and narrow the depth of field considerably with the focal length set to 400mm.

[80–400mm lens at 400mm, 1/125 sec. at f/5.6]

Choosing a viewpoint from above and then shooting down can often reveal some new exciting compositions of tired and worn-out subjects. Most often, a high viewpoint is combined with a wide-angle or "normal" lens. Rarely is it used with a telephoto, unless you're really high up, such as on the rooftop of a skyscraper or in a helicopter. But since I was in one of those rule-breaking moods, I shot this picture of my friend Fabrice while looking down from my second-floor window (opposite). Again, solely due to the telephoto's inherent compression of space, the normally 6' 2" Fabrice was reduced in size. Holding my camera, I chose to focus on the sunglasses on top of his head.

[80–200mm lens at 160mm, 1/125 sec. at f/8]

Exercise: Seeing with the Telephoto

Two qualities of the telephoto are its inherently shallow depth of field and its ability to compress the relative position of objects in a scene, thereby giving the impression that the space is "crowded." Try this great visual tele-zoom exercise that I know will help you "see" with this unique lens. Take out your camera and tele-zoom, and frame a person right in the middle of the viewfinder with the lens set to its shortest focal length; for example, if using a 60–300mm, set the lens to 60mm. Make certain that the person is *not* standing up against a wall or hedge, but rather is at least ten feet away from any background. Also make sure to frame the subject so that the head is at the very top of the frame and the feet are at the very bottom. Now take the picture.

Then, zoom the lens to the 135mm focal length *and* walk backward until the person's head and feet are once again near the very top and very bottom of the frame. Take a picture. Notice that when you frame the person at the shorter focal length, the background is far more discernible than when you photograph the person in exact proportion at the longest focal length. This lack of depth of field (the fuzzier background) at the longer telephoto range is why experienced photographers choose this longer telephoto range for selectively focusing subjects such as flowers and simple portraits.

If you can record this effect with a moderate telephoto lens, such as those in the 135mm range, imagine how much fuzzier you can make backgrounds with the 200mm, 300mm, and 400mm focal lengths. Interestingly enough, the closer you physically move toward your subject, the more diffused and less defined your backgrounds become. In effect, you can turn that busy and colorful wall of graffiti into a sea of multicolored tones by simply choosing to photograph your subject ten to fifteen feet in front of the wall with the tele-zoom set to 200mm or 300mm.

There are also the super telephotos, which range in size from 500mm to 2000mm, but they are seldom used by amateurs—not because they aren't fun to work with, but because of their exorbitant cost. One camera manufacturer currently sells its 600mm F4 lens for $7,800. Any takers? Obviously, these lenses are useful, but they're reserved, for the most part, for the professional or serious amateur photographer, especially those who shoot sports and wildlife.

If your curiosity about these longer telephoto lenses is too much to ignore, consider calling up the local "pro" camera shop. Chances are really good they have one of these "big guns" available on a daily or weekly rental basis. With a little preplanning, renting one of these big lenses could reap big rewards. Who knows? Perhaps on your next African photo safari, you may be the one who captures the "kill" in a fresh and exciting light and, before you know it, has made $10,000 on that one image—and all for the price of a rented lens.

Macro Photography

Sooner or later, most photographers develop an interest in seeing the world from a close-up point of view. The camera industry, now more than ever, has accommodated this desire by manufacturing a multitude of different focal length zoom lenses—many of which offer a macro or close-focus feature—as well as close-up filters, extension tubes, and true macro lenses. All of this equipment is designed to allow photographers to explore worlds that would otherwise pass by unnoticed. Sometimes, you may find yourself getting so close to your subject that reality fades away and worlds of geometric and microscopic elements emerge.

Since close-up, or macro, photography offers unlimited possibilities of exploration, I often prescribe the close-up/macro lens to students enrolled in my Internet photography courses as the antidote for times when they lament, "I couldn't find anything to shoot this week." Consider the world view from the perspective of an ant and it soon becomes apparent that the world has just gotten bigger—much, much bigger. And when this new ground is explored solely with the vision of the

close-up or macro lens, it is no surprise that, even in one hundred lifetimes, one would have barely scratched the surface.

Close-up or macro photography involves, not surprisingly, a lot of unusual camera positions and subsequent points of view. Again, you will find yourself spending a great deal of time on your knees and belly, as well as on your back. There's also the added complication of a shallow depth of field due to the close focusing distances even when using apertures as small as $f/22$. One of the surest ways to overcome this limited range of sharpness is to keep the film plane parallel to the subject whenever possible and use a firm and steady pair of elbows or a tripod that has collapsible legs that spread all the way to ground level.

Although close-up or macro photography has long been associated with nature subjects, don't limit your macro vision to that. I made my departure from shooting *only* nature close-ups a long time ago, choosing to also explore the local junkyards, alleyways, and even an occasional dumpster. The willingness to be open to any subject is a sure sign of learning to see creatively.

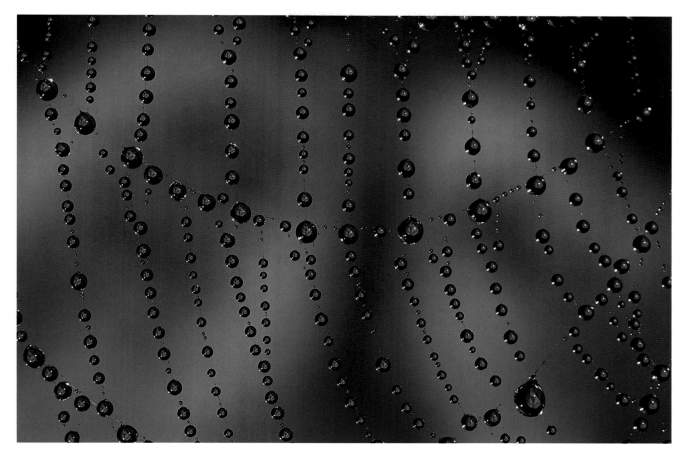

Singapore's Sentosa Island boasts a butterfly park that is home to more than 4,000 butterflies. It's a butterfly-lover's paradise. Experience had already taught me that this type of subject matter requires an extension tube. With my camera, Nikkor 80–400mm lens, and 36mm extension tube, I was ready for the hunt. I didn't have to travel far, as this was a netted enclosure and there were literally butterflies everywhere. In composing the image opposite, I made it a point to choose a viewpoint that would keep the butterfly parallel to the film plane, thus assuring the necessary sharpness. With an aperture of f/8 and the resulting limited depth of field, I was also assured of rendering the two foreground palm fronds as out-of-focus areas of color.

[80–400mm lens, 36mm extension tube, 1/30 sec. at f/8]

Following a quick breakfast, I strode out into my backyard, anxious to find a spiderweb or two. The night before, the weatherman promised a lot of early morning dew—just what the close-up photographer needs to make some truly compelling spiderweb images. It didn't take me long to notice one, and I grabbed my Micro Nikkor 105mm lens, camera, and tripod. I chose a viewpoint that would put the subject parallel to the film plane, thus assuring sharpness from the top of the web to the bottom. Since this spiderweb was among rows of dahlias, I got the added bonus of the flowers forming an out-of-focus background hue. *Note:* The depth of field can be very shallow when shooting close-ups—these dahlias were a mere twelve inches away from the web.

[105mm lens, 1/15 sec. at f/16]

Extension Tubes

I'm not a big fan of close-up filters; I've never been pleased with their optical performance. On the other hand, I am a big fan of extension tubes. Extension tubes are nothing more than metal rings that fit between your camera's body and lens. They "extend" the rear element of the lens away from the camera's film plane, and optical law states that the farther the rear element is from the film plane, the closer you'll be able to focus. Since extension tubes have no added glass (they are just hollow metal tubes), they don't degrade the sharpness of the lens.

So, what lenses do I recommend using with extension tubes? My personal favorite combination is a 36mm extension tube with a 300mm or 400mm focal length lens. As you may know, these long telephotos do bring distant subjects up close, but they also have one major drawback—their inability to focus really close. Normally, these lenses cannot focus any closer than fifteen feet, but with the aid of an extension tube, their ability to focus closer is improved.

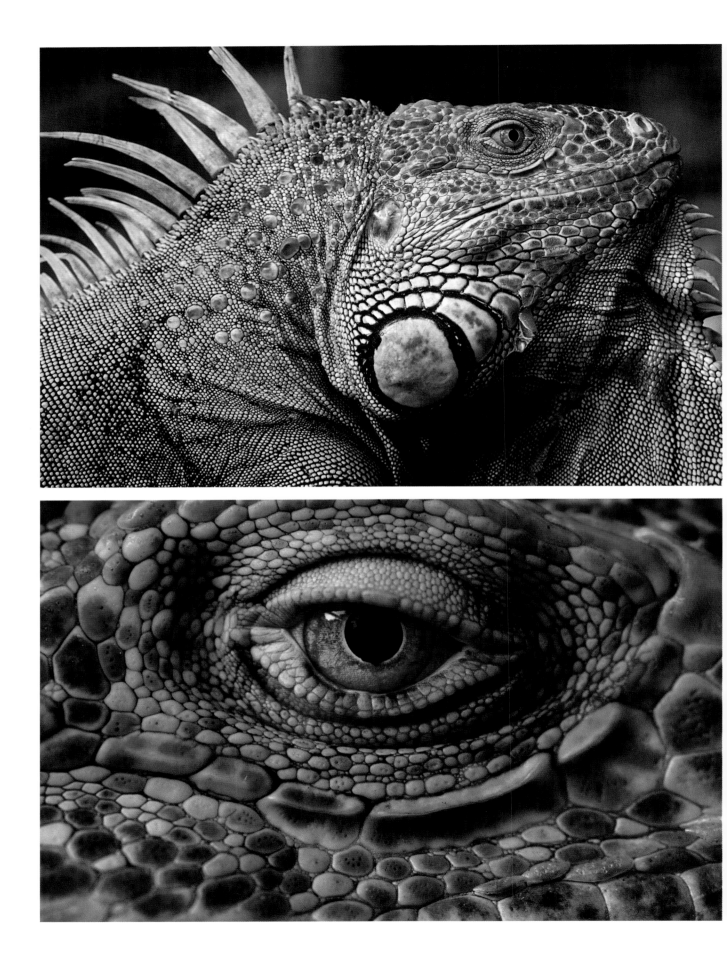

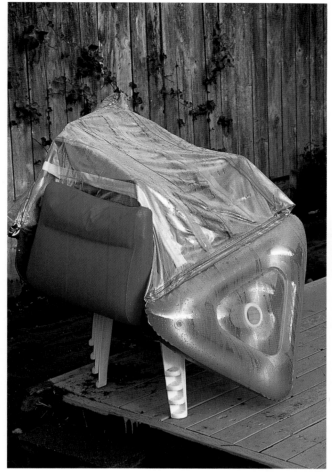

know of no lens that can break through those feelings of lethargy and apathy quicker than the macro or close-up lens. All you have to do is point it at almost anything. While visiting my brother in Seattle, I awoke to find his backyard covered in dew. Deflated and slung over a chair was one of his summer remnants: a lone inflatable raft.

Although the air had gone out of it, it was still teeming with life—very bright and colorful. Over the next twenty minutes, I managed to shoot more than seventy graphic, full-frame compositions of line, texture, and pattern. I felt wonderful!

[This page, both photos: 70–180mm lens, 1/15 sec. at f/32]

There's nothing like spending a very leisurely afternoon among over fifty iguanas inside an open-air garden, this one in Singapore. I was free to roam, as were they. Toward sunset, they appeared even more lethargic than they were earlier in the day, and it was my hope that I could fill my entire frame with the lone eye of one iguana surrounded by the beautiful texture of its skin. My earlier attempts in getting close enough had made the iguanas get skittish and run off.

I chose one particular iguana because it, more than all the others, appeared to be the most tired, as well as the oldest. I reasoned that age and fatigue would be my allies. Slowly, I crawled toward it, all the while keeping my camera and Micro Nikkor 70–180mm lens to my eye. With my aperture set to f/16 I had already adjusted the shutter speed to 1/60 sec. All I needed was to keep my eye on that viewfinder. Occasionally, as I got closer I would fire off a frame or two but, within minutes, was almost there. As I finally reached that point at which I could focus no closer, I saw that my viewfinder was filled with the lone eye and the surrounding texture.

[Opposite, both photos: 70–180mm lens, 1/60 sec. at f/16]

ELEMENTS
OF DESIGN

What Makes a Striking Image?

When asked what kind of photographs command the most attention, my answer is always the same: They most often involve commonplace subjects composed in the simplest way. They're successful because they're limited to a single theme or idea—and they're always organized without clutter. These powerful compositions are in sharp contrast to many of the pictures taken by amateur photographers today. Amateurs, in their haste to record the image, end up with pictures that often have too many points of interest, or in some cases lack a single interest. The resulting lack of direction and subsequent confusion alienates the eye, forcing it to move on, seeking visual satisfaction elsewhere.

Imagine finding yourself lost out on the open road. You finally see a lone gas station up ahead, and you are hungry to discover the route back to the interstate. You ask the attendant for directions, and he begins to offer plan A and plan B and plan C, each with varying degrees of very specific details. Rather than having found the clear, simple, and concise directions you were seeking, your brain is now swimming in a sea of even greater confusion. Clear and concise directions are all that you want. And, that's what most of us want. We want to know the plan, the schedules, the dates, the time. Without order,

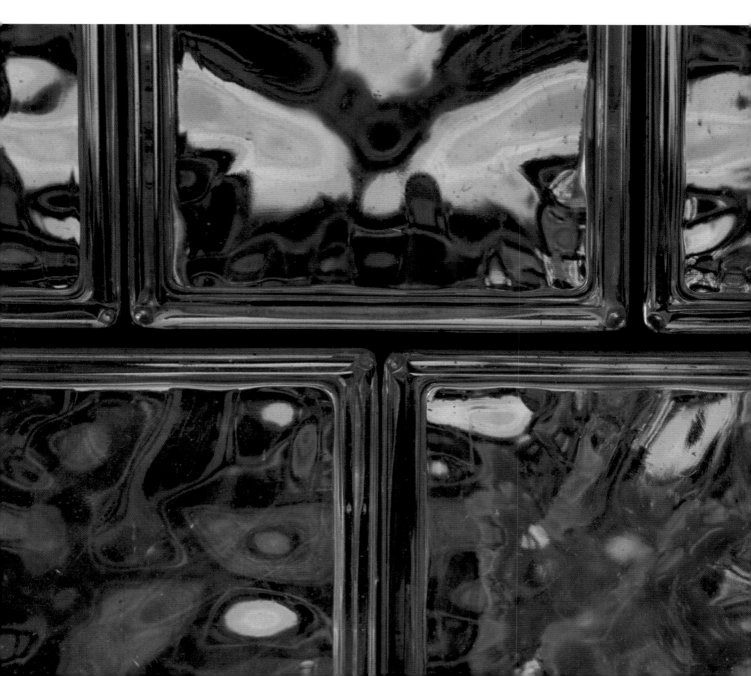

chaos will soon be upon you; and, with chaos comes stress and with stress comes an inability to perform well—and a poor performance taxes one's self-esteem.

Successful photographs rely on order, too. And the elements that bring order to photographic composition are line, shape, form, texture, pattern, and color—these are the elements of design. Every photograph, successful or not, contains at least one if not several of these elements, regardless of the subject. All of these elements have tremendous symbolic value—particularly line, texture, and color. They can be experienced as either hard or soft, friendly or hostile, strong or weak, aggressive or passive. Most of the time, we see and utilize these elements with unconscious abandon. Your memory and your life experiences affect your sensitivity to various visual components, and this in turn affects how you use them in your compositions.

These glass blocks are part of a short wall enclosing a friend's front porch. Is this image "art"? As with all art, the answer is subjective, but one thing is certain: It's an image with impact—and for good reason. It's an image of shape, line, texture, and color, an image that's made up solely from the elements of design.

[35–70mm lens, 1/60 sec. at f/11]

Exercise: Mastering the Basic Principles of Design

Years ago, I began giving students an exercise that I still use today. It can help not only expand your vision but also reveal parts of your inner psyche: your likes and dislikes.

Gather up about eighty of your images, preferably those without people in them. (If you cannot find eighty people-free images, gather up eighty images with people in *all* of them.) Set them aside for a moment, and take a sheet of blank paper and draw six columns on it. At the top of each column, list one of the following: line, shape, form, texture, pattern, and color. Now, begin looking at your pictures, one by one, with a critical eye. Carefully study each one, and make a check mark in the columns that best describe the elements that dominate the composition. It is more than likely that one or possibly two columns will have more check marks than the others. Consciously, we all favor certain design elements. Both the content and the arrangement of your pictures reveal something about your psyche—assuming, of course, that your reason for taking pictures flows from your own feelings and responses to the world around you, and isn't simply an attempt at duplicating someone else's style.

Take notice of which columns have the least check marks. These are your "weaknesses," so grab your camera and head out the door with the goal of creating imagery that addresses these weaknesses. Take only your telephoto or telephoto zoom. Either of these lenses reduces perspective, which enhances good visual design since the factor of depth has been eliminated. As discussed earlier, telephoto lenses also have a narrow angle of view, which can further eliminate surrounding clutter and let you focus on the specific visual elements you want to emphasize.

When I wrote the first edition of this book back in 1988, my line and pattern columns were heavily checked. Fast-forward to the year 2003, and I have, for the first time, an equal amount of check marks under all of the columns—and for the first time that includes the texture column! Mastering the basic principles of design will be a liberating experience! These principles will allow you to chart your course and set sail on an ocean of ideas.

Line

Of the six elements of design—line, shape, form, texture, pattern, and color—which is the strongest? Line! Without line there can be no shape, without shape there can no form, without shape and form there can be no texture. And, without line or shape, there can be no pattern.

A line can be long or short, thick or thin. It can lead you away or move you forward. It can be felt as restful, rigid, active, soothing, or threatening. The emotional meanings of line cannot be overlooked. Some of us experience a thin line as sickly or unstable, and yet others see it as sexy, cute, and vulnerable. A thick line for some may feel stable and reliable, but for others unhealthy and stern.

In nature, curvilinear lines dominate. They are the wind, the rivers, the surf, the dunes, the hills. Curvilinear lines are experienced by most as soft, gentle, restful, and relaxing. Jagged lines are also present in nature, the most obvious being mountain ranges and their peaks. They have also shaped much of history, as wars were fought with arrows, knives, spears, and swords. Jagged lines can be experienced as sharp, dangerous, forceful, chaotic, and threatening. Even the investor on Wall Street is all too familiar with the chaos caused by the jagged line.

The diagonal line evokes feelings of movement, activity, and speed. It is solid; it is decisive. The cyclist knows the diagonal line presents a challenge going up and the exhilaration of speed going down. The diagonal line will always breathe life into an otherwise static composition. Being conscious of the subtle feelings associated with lines will allow you to manipulate a photograph's emotional impact.

While standing in a line outside a Hindu temple in Singapore, the woman in front of me presented a fabulous composition with her long black line of hair contrasting against her bright orange sari. Since she was a bit shorter than me, and so that I could keep the line of her black hair parallel to the film plane, I squatted down just a bit before making the photo. It was easy to do this since I was holding the camera and not using a tripod.

It might be a bit unnerving for some photographers to take this kind of shot for fear the woman would turn around at the sound of the camera shutter going off. If she had (she didn't), I would have simply explained the reasons for my enthusiasm and hoped that she would have been flattered. Although I believe in asking first before taking someone's picture, there are situations in which the timing won't allow it.

[35–70mm lens, 1/250 sec. at f/8]

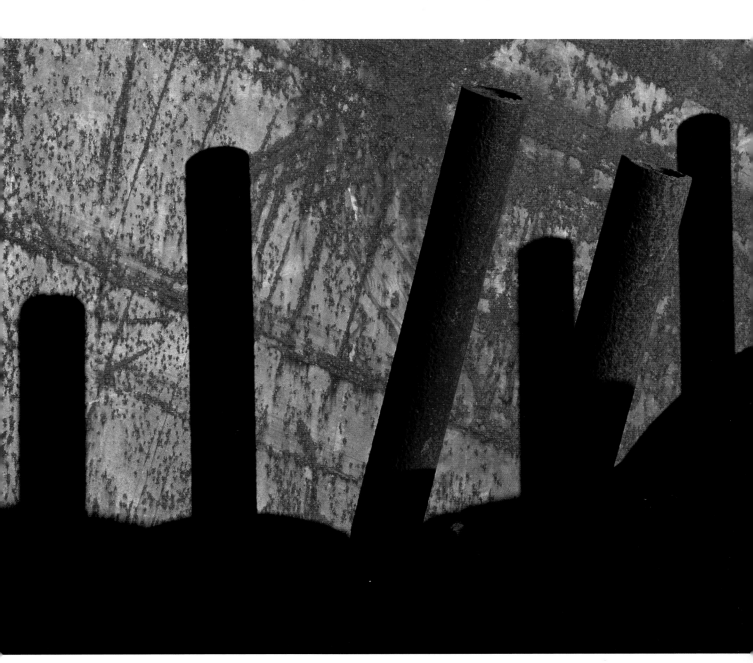

When looking for subject matter, nature is often the clear choice for most outdoor photographers. Perhaps that's why I especially like to challenge my Internet photography students to apply their learned techniques to "unlikely" subjects in "unlikely" locations, and the local junkyard or wrecking yard continues to be high on my list of these spots. I caught sight of these wonderful lines of rusted pipes standing in an old rusty barrel against a background of an equally rusty piece of steel sheeting. The early morning sidelight and the resulting shadows created some really nice depth and also emphasized the texture of the unusual subject. Note, also, the diagonal lines formed by the background rust. This combination of line and sidelight creates an image full of texture, movement, and depth.

[80–200mm lens at 150mm, 1/125 sec. at f/16]

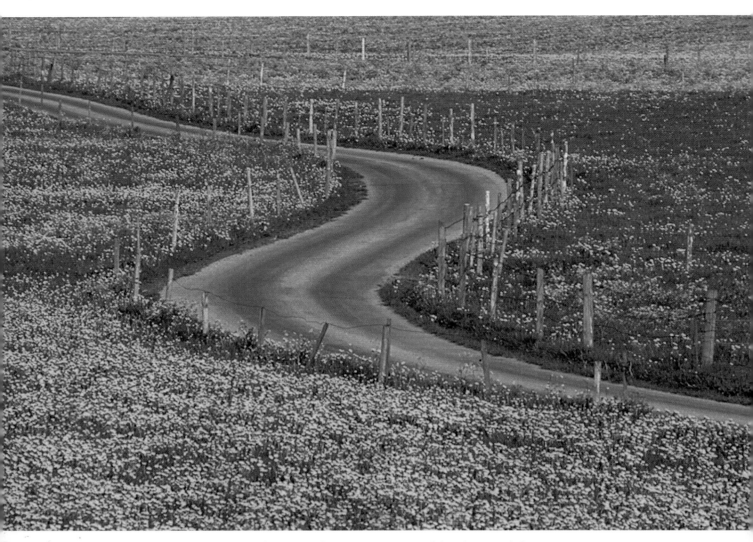

Although the S curve occurs abundantly in nature—for example, a meandering stream—it's also evident in the man-made roads and trails of the countryside. Considering that this is a flat landscape, someone had the "compositional foresight" to build this road in the form of a simple S curve through the pastureland of Bavaria, Germany. Clearly, the road could have been built straight since there are no rocks or trees to avoid.

When I saw this scene in my rear view mirror, I felt compelled to stop the car and photograph it. With my camera and Nikkor 300mm lens mounted securely on a tripod, I chose an aperture of f/32 for maximum depth of field and then simply adjusted the shutter speed to 1/30 sec. This image was later used by Volkswagen of America in their 1996/97 new-car catalog that was sent to all the dealers. Volkswagen didn't buy the use of the photograph from me directly but from my stock agency in New York. When I made the image, I certainly did not have Volkswagen in mind—I simply wanted to capture and convey the meandering, carefree, and stress-free road. You just never know if, when, how, or by whom the images you make today will ever be used.

[300mm lens, 1/30 sec. at f/32]

Unlike the S curve of the road above, note the power of the two converging parallel lines formed by the rows of trees flanking this straight road in West Freisland, Holland. This direct type of line is often associated with the business world. The message is "stay the course, keep your eye on the goal ahead." There's no slow, meandering message here! It knows where it's taking you.

[80–200mm lens at 135mm, 1/30 sec. at f/22]

Nowhere can one find more man-made diagonal lines than in the industrial world. While on assignment in Nevada for a gold-mining company, I photographed a worker on a nearby conveyor. There's a lot going on in this image, compositionally speaking, and much of it is due to line. The horizontal line at the bottom of the frame anchors the many diagonal lines that are "free" to move without fear of "collapse." Additionally, note the use of the triangle shape, which frames the background truck. It's clear that the truck is in an active state as indicated by the diagonal line of its bucket.

[80–200mm lens at 200mm, 1/30 sec. at f/32]

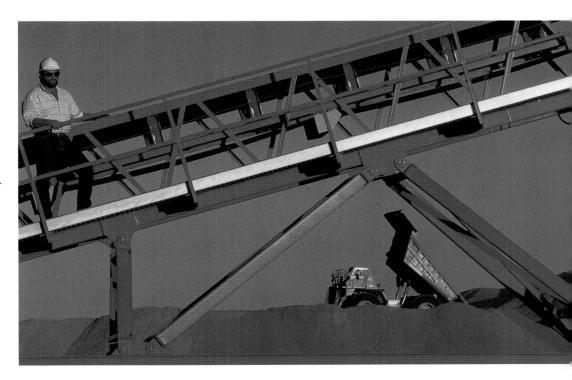

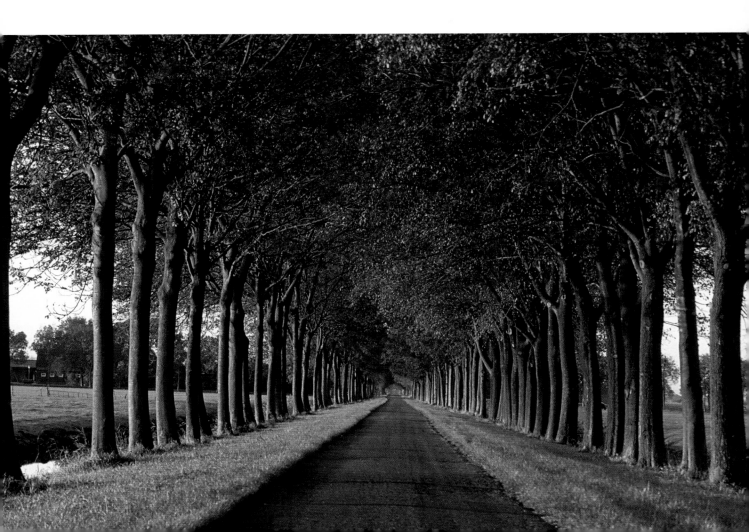

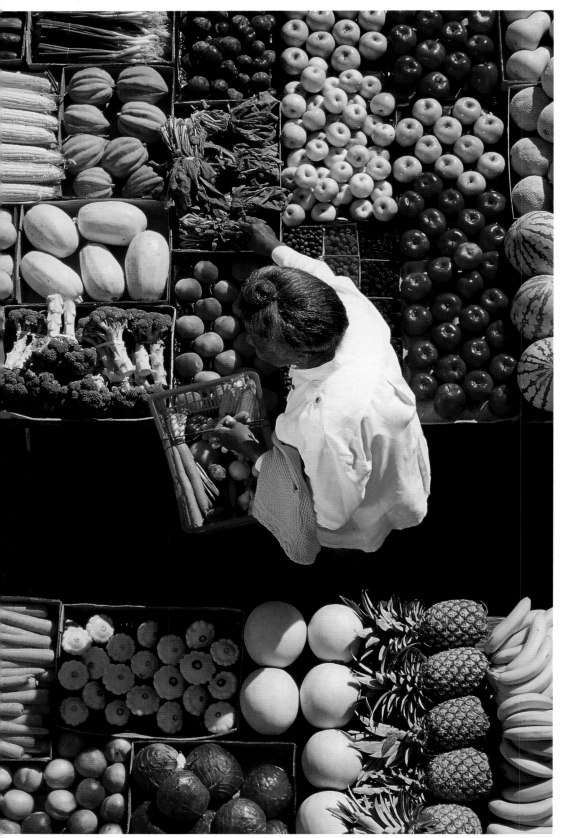

Whenever the opportunity presents itself, I love to shoot looking down on my subjects from above—the higher up the better. I was hired by a New York advertising agency to shoot several ads for a new arthritis drug, and one of the ads called attention to the need for a healthy diet in combination with the drug. It was decided that an overhead view of a fruit stand with the model buying fruits and vegetables would be one of their ads. Knowing how difficult it was going to be to find an uncovered fruit-and-vegetable stand, we decided to create our own. Setting up tables in a large parking lot, with a real fruit-and-vegetable stand only fifty feet away, we bought and then arranged the various fruits and vegetables one would normally find.

From atop a twenty-foot stepladder, I began to shoot downward with my camera and 35–70mm Nikkor lens. With my aperture set to f/11 and a shutter speed of 1/250 sec., I fired off a number of horizontal and vertical images similar to the example shown at left. I also took a number of images with the camera turned to a diagonal position (opposite page). It's clear that the strong diagonal placement of the space separating the stands creates a much more active composition. It was my feeling that if the drug held the promise of making an arthritic patient more mobile (and therefore active), then the image should convey that, as well.

[Left and opposite: 35–70mm lens, 1/250 sec. at f/11]

Shape

Shape is more fundamental than form, texture, or pattern because shape is the principal element of identification. You may think you smell a fragrant rose, but until you see its shape, you can't make a positive identification. You may hear a sexy voice on the radio, but unless you actually see the speaker, who knows if he or she has that sexy shape?

From prehistoric through modern times, man's need and ability to identify objects by shape has endured. This ability—or lack thereof—provides, alternately, security and anxiety. If the caveman could not readily identify the shape of that herd on the horizon, he very well might have walked right into a family of saber-toothed tigers. During World War II, if soldiers from differing countries hadn't had different helmets, they might have ended up shooting at their own comrades. As the shape of the car comes over the crest on the horizon, you can now relax knowing that, although she arrived later than planned, your daughter has returned home safely from college. Horror movies play off our anxiety about the shape of the unseen, and most have a standard script that leaves the monster unseen for better effect. No one actually sees the creature, leaving the imagination to run wild. The audience wants this "thing" identified, because seeing its shape would finally reduce, if not eliminate, everyone's anxiety.

When composing a photograph that depends primarily on shape, there are several things to remember. First, shape is best defined when the subject is frontlit or backlit. Secondly, there should be a strong contrast between the shape and its surroundings. If you want to shoot silhouettes, there are no better times than just before sunset and several minutes following, as well as several minutes before sunrise and several minutes after. Form and texture both vanish at these times, leaving only stark outlines and profiles against the sky. The silhouette is the purest of all shapes, so it is not surprising that silhouettes continue to be the most popular shapes to shoot.

There was a time when it seemed all I ever shot were silhouettes. Although I don't shoot silhouettes with the same fervor today, I still enjoy making them. While vacationing on the island of Maui, I looked forward to shooting a stark and graphic composition of my wife Kathy holding up our daughter Chloe against the strong backlight of a sunset. As you can see, at this time of day form and texture have all but vanished, leaving only stark shapes. To fill the frame with only my wife and daughter against the setting sun, it was necessary to change to the telephoto lens. The use of a 400mm lens for the top image, opposite, cleared out the clutter seen in the image below it and left me with a frame that was filled with my wife and child.

It's also important to note the added shape of the sun. The circle is by far the strongest shape. It can symbolize not only the sun but the moon, Earth, and planets, and it evokes feelings of completion, universality, psychological wholeness, and warmth. A circle will oftentimes unify a composition by providing a center of power, and no circular object is more powerful than the sun. To get the top image, I mounted my camera and lens on a tripod, set the aperture, and adjusted my shutter speed with the camera pointed at the sky to the left of the sun. I then recomposed and shot the scene.

[Opposite, top: 400mm lens, 1/250 sec. at f/11. Opposite, bottom: 35–70mm lens at 35mm, 1/250 sec. at f/11]

As the sun was nearing the horizon, it illuminated the buildings along the Saône River in Lyon, while the small footbridge was cast in shadow. This stark contrast between the shape of the bridge and the very colorful, brightly lit buildings was something I'd always noticed, but it was several months before I felt compelled to photograph it. This time, I noticed a couple approaching the bridge. I noticed by their hand gestures that they appeared quite enthused, and the man was also carrying an opened umbrella. It struck me as odd to see someone with an opened umbrella on a day when there was no risk of rain. I broke out my camera and lens, and mounted them both onto my tripod. I then framed the section of silhouetted bridge onto which the couple would soon be walking.

Little did I expect to see what happened next. As they came into the frame, they started to spin in a circle, complete with the opened umbrella, as if to dance in the fashion of Fred Astaire and Ginger Rogers. It was soon over, this "dance of life," and on their merry way they went.

[80–400mm lens, 1/250 sec. at f/11]

Form

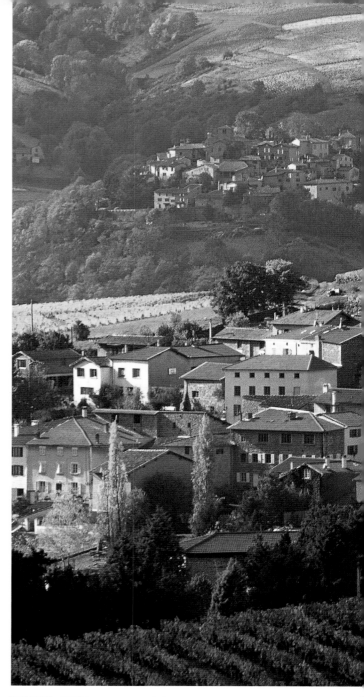

Basically, form is seen in three dimensions, while a shape has only two. Form assures us that an object has depth and exists in the real world. Since communicating form depends on light and the resulting shadows, it's best to photograph a subject under sunny skies and sidelighting to reveal its form. The contrast between the light and dark areas of a sidelit shape give it form.

Squares, rectangles, triangles, and circles evoke different emotional responses. When the forms of these shapes are revealed (usually with sidelighting) their messages are amplified. A backlit circular shape represents wholeness, yet when photographed sidelit, the form is revealed and the curvilinear shapes that result take on sensual meanings, reminding us of the human form. The three-dimensional forms of rectangles, squares, and triangles suggest the man-made world.

When I made this series of pictures in Beaujolais, France, the sky overhead was filled with puffy clouds lingering from the early morning rain showers. As each cloud passed beneath the sun, a big shadow fell across the landscape, covering portions of the scene. As the cloud moved on, this shadow also moved, alternately covering and revealing the form of different areas of the landscape. With my camera and 80–200mm lens mounted on a tripod, and with my aperture set to f/16, I adjusted my shutter speed until 1/125 sec. indicated a correct exposure for whichever part of the landscape was in the light. I made a point to shoot more than a dozen shots, each one uniquely different due to the subtle change in the landscape's form caused by the cloud overhead.

[All photos: 80–200mm lens, 1/125 sec. at f/16]

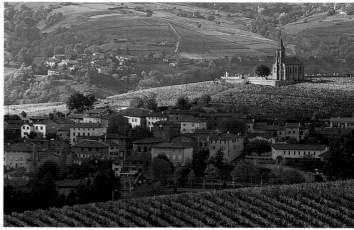

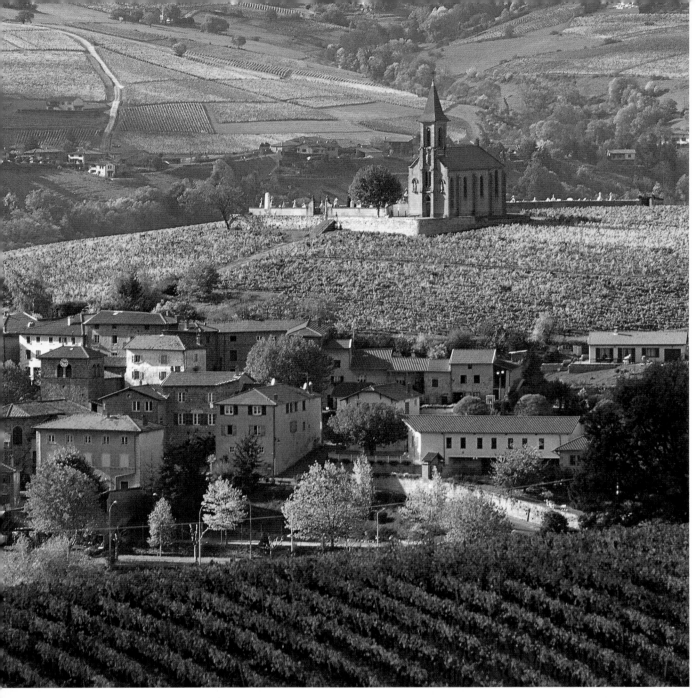

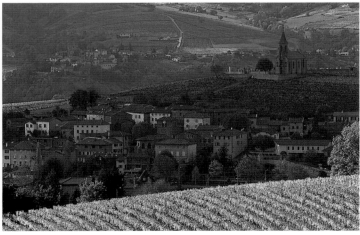

Landscape photographers know the importance of form and shape. Both are often vital to the success of a landscape image. Sidelit landscapes are most often preferred, since sidelighting reveals form better than any other lighting condition. In this series of photographs, I began near the edge of this field of rolled bales of hay, and chose a sidelit point of view and a composition that emphasized the dramatic sky. Handholding my camera with 17–35mm lens, I set the aperture to f/16, adjusted the shutter speed to 1/125 sec., and made the first exposure (opposite, top). I then walked farther into the field, getting closer to the bales, and made another photograph (opposite, bottom). Then I moved even closer until one bale filled almost half of the lower portion of the frame (below). In all three photographs, form and shape dominate the composition.

[All photos: 17–35mm lens, 1/125 sec. at f/16]

Texture

Perhaps no element of design is more capable of exuding deep emotion than texture. Even if you only witness someone being thrown from a bicycle, a chill goes down your spine as you see the person skidding, hands and face down, across a gravel pathway. In our daily language, we use texture to describe most everything. A rough day, a soft touch, a sharp mind, a dull movie, a sticky mess. A woman's soft voice may arouse delicate or vulnerable feelings, but a man's gravelly voice may elicit fear or feelings of aggression. A hard-nosed boss seldom wins the affection of employees, whereas the *smooth*-talking boss often does. These are just a few examples of texture's influence.

Although we use texture as a means of describing events in our lives, it's not as readily apparent in photographic work. Texture, unlike line or shape, doesn't shout to make itself known. Of all of the elements of design, it is the one element that is most often "hidden."

The challenge in seeing, as well as conveying, texture depends on one critical element: lighting. A compelling image of texture—unlike line, shape, pattern, or color—is dependent on low-angled sidelight. So, it's imperative that you search for texture on sunny days in the early morning or late afternoon hours. Although some texture-filled compositions are obvious, like the sidelit bark of a tree, others require much closer inspection, and you may find your macro lens getting lots of use.

Once you begin to see—and compose with—texture, you may discover its other use in creating compelling landscape imagery: As a foreground element in a vast compositional landscape, texture can arouse a heightened emotional response from viewers as their sense of touch is ignited.

When I awoke one morning, I had frost covering much of the windows *inside* my house! And why not, since the house I was living in at the time had a broken oil furnace and the temperatures overnight had dropped to single digits? As one who believes that when life gives you lemons you should make lemonade, I was quick to grab my gear and shoot these magical details (opposite). With my camera and Micro Nikkor 105mm lens on a tripod, I moved in close on a number of frosty textures. With the lens and camera parallel to the window, I chose an aperture of f/11 and simply adjusted the shutter speed to 1/30 sec.

[105mm lens, 1/30 sec. at f/11]

While awaiting the sunset along Oregon's central coast, I took note of this small trickling stream of water that flowed out of a nearby sandstone cliff behind me. The warm late afternoon light and the blue sky overhead were reflecting in the water as it cut a meandering path through the sandy shoreline (left). With my camera and 80–200mm lens mounted securely on a tripod, I zoomed out to 200mm and filled the frame with texture (above). For maximum depth of field, I set the aperture to f/32 and adjusted the shutter speed to 1/30 sec.

[Top: 80–200mm lens at 200mm, 1/30 sec. at f/32. Bottom: 35–70mm lens at 35mm, 1/60 sec. at f/32]

While on assignment for a mining company in Nevada, I was shooting some distant scenes, positioning myself on this walkway of a rather large outdoor conveyor. After I had completed my shots, I headed back down the walkway and couldn't resist the industrial pattern that lay at my feet. The mere thought of walking or, better still, running barefoot up or down it sends a chill through me. Such is the power of texture—made even more evident when "amplified" by pattern. With my camera and Micro Nikkor 70–180mm lens mounted on a tripod, I got down low and filled the frame with the walkway pattern (below). Once you begin to see and compose with texture, you soon discover other ways to use it in the "bigger picture."

[Top: 35–70mm lens at 35mm, 1/60 sec. at f/16. Bottom: 70–180mm lens, 1/30 sec. at f/22]

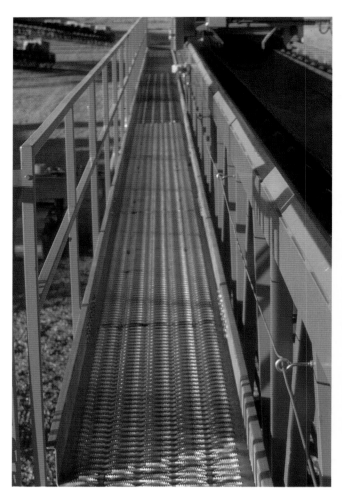

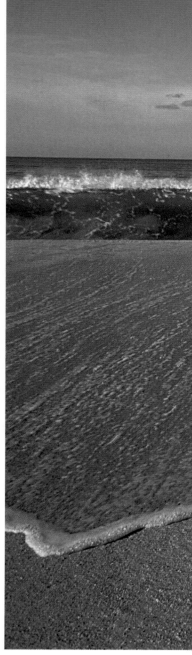

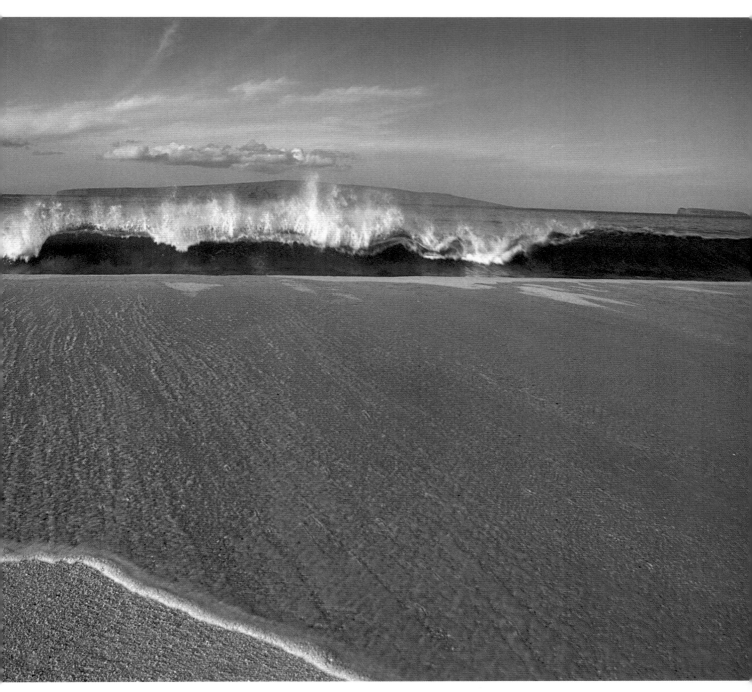

Along the south shore of the island of Maui lies Makenna Beach. It's a popular beach, but fortunately for me, the evidence of its popularity doesn't begin to show until shortly after 10:00 A.M. Arriving just after sunrise, I had the beach all to myself. I spent fifteen minutes or so watching the incoming surf, discovering its pattern of creating a much bigger wave every fifth wave. It was this much bigger wave that held my interest, as it was the only one capable of truly coming ashore. Holding my camera and lens while lying on my belly at the edge of the sandy beach, I was ready and began firing at will once the fifth wave broke. With such a large portion of the frame filled with the texture of the beach and the remnants of ocean surf, it's no surprise if you *feel* like you're at the beach.

[17–35mm lens at 17mm, 1/125 sec. at f/22]

The opportunity to elicit a strong emotional response with texture presented itself in the harbor town of Leeuwarden, Holland. I caught sight of a large fishing net hanging from one of the many boats in the harbor and chose to fill the frame with its texture while also framing some of the houses in the background (right). The rough and somewhat abrasive texture of the net calls attention to the rough and sometimes harsh and abrasive life of the fisherman. I set the focal length to 35mm and the aperture to f/22 so that I would render everything sharp, front to back.

[35–70mm lens at 35mm, 1/30 sec. at f/22]

Texture as a background can most often produce an exciting and emotion-filled composition. A simple road sign with a wall of texture behind it (opposite, bottom) elicits a strong response: I doubt if anyone would think this road sign is out in the countryside; the man-made feel of the back- ground texture leaves no doubt that this sign is in or very near an industrial area.

Similarly, even without the addition of two Ukrainian steel mill workers (above), the heavily textured wall behind them would strongly suggest the industrial world. If you were to place these same two men against a background of out-of-focus green tones, the image would not have nearly the same impact. Such is the strength of texture in its ability to spark our senses.

[Opposite, bottom: 35–70mm lens, 1/125 sec. at f/8. Above: 35–70mm lens, 1/60 sec. at f/8]

Pattern

Six months following my introduction to photography, I found myself experiencing a level of enthusiasm that seemed to have no limits. On one particular day, I was focusing my camera and lens on the bright red tomato and deep green cucumber slices that I had just prepared as part of my lunch during a camping trip. The combination of the colors, the texture, and most of all the pattern caused me to shoot more than several rolls of film.

I later realized that this "discovery" not only lead me to more and more pattern-filled opportunities, but that it also revealed some inner psychology about myself. All the elements of design elicit some very profound emotional responses, and for me, pattern had this uncanny ability to evoke emotions of stability, consistency, and belonging. It also felt safe, secure, and reliable because it was predictable. Whether on the job or at home, all of us have some degree of predictability. This predictability is expressed as patterns of behavior. A burglar looks at pattern as a means to successfully steal from you while you're away at work; the detective looks for pattern as a means to capture the burglar. A psychologist looks for pattern as a way in helping us understand our behavior, while a parent becomes accustomed to the pattern of the newborn. Without pattern, our world would be pure chaos.

Several years following my encounter with the sliced tomatoes and cucumbers, I made another discovery about pattern. I had arrived early in the morning at Indian Head Beach, a few miles north of Cannon Beach, Oregon. The morning drizzle had brought a shiny glare to the thousands of small, rounded rocks that covered the shoreline—pattern in abundance, to be sure. As I walked atop this patterned display, my eyes caught sight of a feather lying among the rounded rocks. I was quick to reach for my macro lens, anticipating a frame filled with a portion of the feather and the eight or nine raindrops that had collected upon it. But, as I was separating the legs of my tripod, I was suddenly hit with the realization that the better shot was of the pattern created by the round and dark-colored rocks in marked contrast to the lone and angular white feather. Since pattern is so predictable, that which disrupts its rhythm and harmony will get your undivided attention—just like a crying baby in church.

As I came out of a local health food store, I was greeted with a passing rain shower. Caught without an umbrella, I took cover under a nearby overhang. Following the few minutes' wait, I returned to my car, and it was then that my eyes caught sight of this tiny "oil spill" in the parking space next to mine. I grabbed my gear from the trunk of the car, quickly mounted my camera and lens on a tripod, and moved in close, making certain to fill the frame in a uniform manner.

[70–180mm lens, 1/4 sec. at f/16]

As I've already mentioned, I love to have any excuse to photograph looking down on subjects, oftentimes from much, much higher vantage points. Although I spend a great deal of time walking upon this good ol' earth, my mind is often asking, "How would my surroundings look from overhead?" After walking along the very popular Bondi Beach in Sydney, Australia, I felt that the answer to this question would be simply amazing, but then came the even more important question: Could I get a helicopter rental on a Sunday, and would a helicopter be allowed to fly above this beach or was it a restricted zone?

Two hours later I was airborne and having the time of my life. With the back passenger door slid wide open and the safety harness secured around my shoulders and waist, I didn't hesitate to lean out the open doorway and make a number of exposures of the varied and random patterns of people and things that lay on the beach below me.

Renting a helicopter is not cheap, of course. For my one-hour ride I coughed up $900, but within three months of placing this photo-graph with one of my stock photography agencies, it had sold on three different occasions for a combined total of $2,700. At this writing, that number has increased to more than $18,000. This certainly proved to be one time when investing in a helicopter rental reaped big rewards.

[80–200mm lens at 200mm, 1/500 sec. at f/8]

From a nearby hilltop overlooking the city of Lyon, France, I was able to shoot the pattern created by these rooftops and chimneys, which were lit by the low-angled sidelight of the soon-to-be-setting sun (below). With my camera and 80–400mm lens mounted on a tripod, I zoomed out all the way to 400mm. As holds true for many pattern images, this photograph would make for a most challenging puzzle.

A similar subject—the rooftop of the city hall in the German town of Nordlingen—is covered in tiles that form a very striking pattern (bottom). To fill the frame with nothing but tiles would have no doubt resulted in a harmonious and rhythm-filled composition, but I chose to "disrupt" the pattern by including the town clock in the shot. Supported by a background of harmonious color and shapes, the clock now finds itself "center stage." Again using a tripod, I set the focal length to 300mm, and I chose an aperture of f/32 for maximum depth of field.

[Below: 80–400mm lens at 400mm, 1/60 sec. at f/16. Bottom: 80–400mm lens at 300mm, 1/30 sec. at f/32]

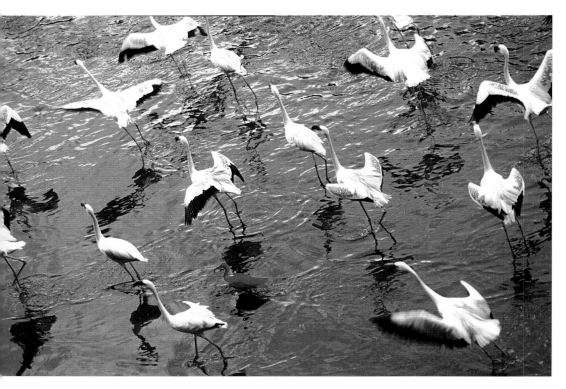

While photographing down on a small group of flamingos at the Jurong Bird Park in Singapore, I was in for a pleasant surprise. Shortly after making several images of only flamingos, an orange ibis flew into the scene, interrupting the pattern made by the flamingos. This "disruption" immediately became the scene's center of attention.

[35–70mm lens at 70mm, 1/125 sec. at f/11]

While on assignment in Singapore, I spent several days in Little India photographing many of the people who live and work there. I noticed one man sitting out in front of his shop reading a newspaper. Following my request to take his picture, he obliged and I simply framed him in front of the patterned background against which he was already seated. Since he "disrupted" the pattern, he became the focus.

[105mm lens, 1/250 sec. at f/5.6]

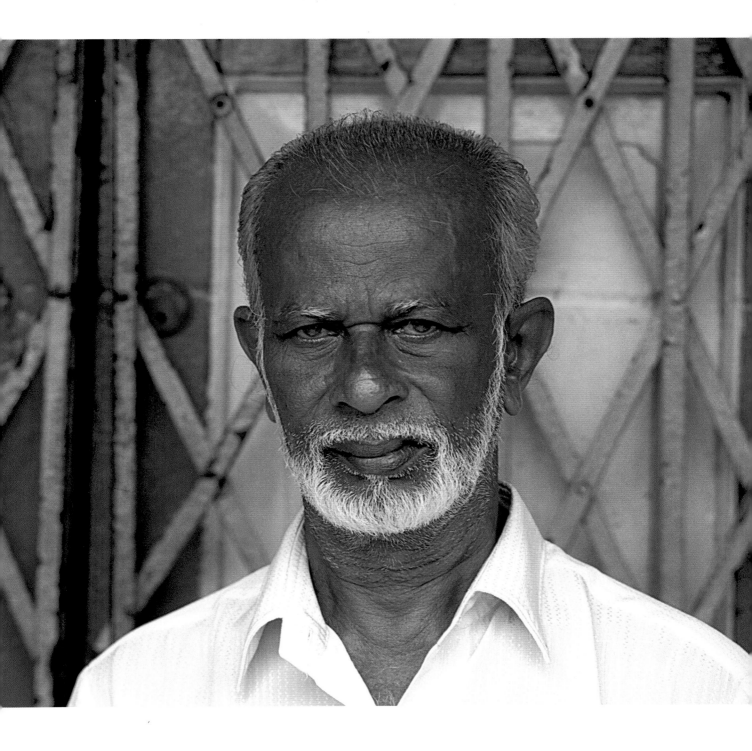

Exercise: Recognizing Pattern

In my on-location photo workshops, as well as in my Internet photography courses, I always suggest first that each student start looking for pattern-filled opportunities. Since patterned compositions are abundant, and since they can often be seen as playful, this is a great way to begin one's journey into exploring the elements of design—and, you don't have to go far at all!

If you're confined to the house for any reason—health, parenting, or inclement weather—don't despair! Set up a small card table (or even use the kitchen table) next to a large window. Consider dumping silverware onto the table (below). Use your tripod to get images that are as sharp as possible. Move on over to the stacked dinner plates and make a patterned composition of their edges. Or, arrange those eight drinking glasses in a pattern and fill each one with water while putting several drops of food coloring in them. Then, look down on them and arrange a colorful pattern of circles.

And, don't forget the patterned composition of drinking straws that you can take with your macro

Next to a south-facing window, I set up my worn-out card table with a blue glossy board on top. I felt this addition of color would bring needed contrast to the silverware that I was about to dump on the tabletop. With my camera and lens on a tripod, I looked at the scene before me and, after doing some minor rearranging, filled the frame with the patterned composition I was seeking.

[35–70mm lens, 1/15 sec. at f/16]

lens or with the addition of an extension tube on your 35–70mm zoom lens. I can think of at least five more ideas just in the kitchen. Can you? When you're done in that room, consider the wealth of new stuff that awaits you in the garage! Expand your search for patterned photographic subjects to flea markets and wrecking yards, or simply walk the streets. If it's raining, take note of the many patterned compositions of raindrops atop the colorful car hoods. Investigate empty parking spaces and discover the miniature "oil spills" that often form there (page 69).

And of course, nature and agriculture are great sources of pattern: fruit and vegetable stands (see the images on pages 54 and 55), ferns, flowers, and

orchards to name just a few. In fact, if there were an award for the best location for pattern, I would have to give it to those outdoor fruit, vegetable, and flower markets that are a permanent fixture throughout much of Europe, as well as along the back roads of America's farmlands. (*Note:* When shooting at many of these outdoor markets throughout the world, *don't* bring a tripod. You—and others—may trip over it.)

The possibilities for photographing pattern are endless. Although your chosen subject may be nothing more than a bunch of red peppers (as in the image on page 6), a very simple yet graphic composition will make you take notice. Pattern *is* everywhere, if you take the time to look.

On a nearby kitchen counter, my wife had just placed a new box of straws for the kids following her trip to the grocery store. I grabbed them quickly before the kids could disturb them, and placed them on the table. The pattern opportunity was obvious, but I needed my macro lens to fill the frame, since the area of multicolored straws was no bigger than three inches square. With my camera and Micro Nikkor 105mm lens mounted on a tripod, I moved in close, filling the frame and shifting the camera's plane so that it was at a slight angle to the ends of the straws (rather than parallel), bringing a sense of movement to the composition, as well.

[105mm lens, 1/8 sec. at f/22]

Color

Some time ago I was sitting in a local café in Lyon, France, reading the day's news in the *International Herald Tribune*. Several minutes following my arrival, two young men walked in and took a seat within earshot of me. What caught my attention was one young man's overstuffed camera bag and the two Nikon F100s hanging from his neck. He was either a very serious amateur or a seasoned professional. Over the course of the next thirty minutes, their discussion centered around photography, and of all that they said, one comment made by the man with the gear stood out the most: "Color is so obvious. Where is the surprise in that? The real art in image-making lies in shooting black and white."

This is neither the time nor the place to begin a debate on what constitutes art in photography, whether in color or black and white. However, this *is* the perfect opportunity to address the fact that color is indeed obvious. It is *so* obvious, in fact, that many photographers don't see it at all! If people really saw color, they would be far too consumed by the need to shoot color *if only* for color's sake.

To really see and become an effective photographer of color there's much to learn. Color has many, many messages and meanings. You must also become aware of color's visual weight and the subsequent impact it has on line and shape, as well as its varied hues and tones.

Perhaps since the advent of language, man has integrated color into language. "Feeling blue?" "He makes me see red!" "I'm green with envy." "The whole town's come down with yellow fever." "We got the red-carpet treatment." "He received the purple heart." "Are you going to watch the Orange bowl?" "He bought them on the black market." "She was as white as a ghost." "Nothing but yellow journalism." "He turned blue."

Although the subject of color is deserving of its own book, if not a whole set of encyclopedias, I will limit my discussion to the primary (red, blue, and yellow) and secondary (orange, green, and violet) colors. Primary colors are called such because they cannot be created by mixing any other colors. The mixing of any two primary colors results in a secondary color: Mixing red with blue makes violet, mixing red with yellow makes orange, and mixing blue with yellow makes green. Color is often discussed in terms of temperature, with reds, yellows, and oranges (associated with the sun) often described as warm colors, and blues, violets, and greens (associated with water and shadows) often described as cool colors.

Red is known as a passionate and powerful color. It is the color of love and the "power tie" in the white-collar world. It is stimulating, exciting, and motivating. It is control, rage, and power. It is the color of blood, stop signs, and brake lights. It is also the color that advances the most of all colors. What this means is, if you were to place red, orange, yellow, green, blue, and violet signs in a field all at equal distances from you, the red sign would appear closer than the others.

Two Sets of Primary Colors

The primary colors that I refer to in the text here—red, blue, and yellow—are known as *subtractive* primary colors. From them we get the subtractive secondary colors—violet, orange, and green. The subtractive color system involves colorants and reflected light. It uses pigments applied to a surface to subtract portions of the white light illuminating that surface, and in this way produces colors. Combining the subtractive primary colors in equal parts produces the appearance of black. Color painting, color photography, and all color printing processes use subtractive color.

However, there is also another set of primaries called *additive* primary colors, which are red, green, and blue. From these we get additive secondary colors—cyan, magenta, and yellow. Additive color involves light emitted from a source before it is reflected by an object; it starts with darkness and adds red, green, and blue light together to produce other colors. When combined in equal parts, the additive primary colors produce the appearance of white. Television screens, computer moniters, digital and video cameras, and flatbed and drum scanners all use the additive color system.

Again, it's the *subtractive* colors that I'm talking about here. They have been used by artists for centuries, and they are the ones you should keep in mind when working with color.

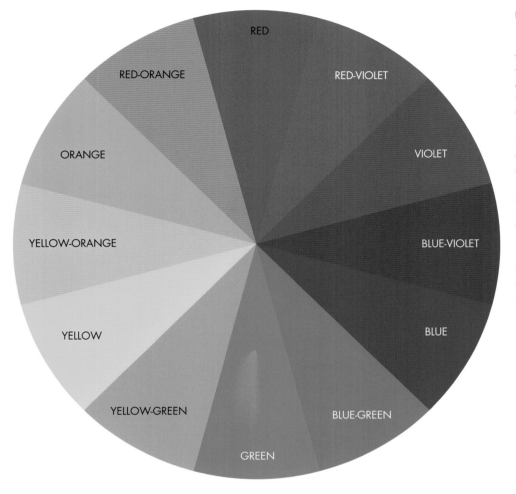

RED

RED-ORANGE

RED-VIOLET

ORANGE

VIOLET

YELLOW-ORANGE

BLUE-VIOLET

YELLOW

BLUE

YELLOW-GREEN

BLUE-GREEN

GREEN

The color wheel is an ordered arrangement of twelve subtractive colors that helps to show their relationships to one another. For example, pairs of colors that fall opposite each other on the wheel are called complementary colors; when placed side by side, these pairs complement and intensify each other. Also, each primary color falls opposite a secondary color, and each secondary color falls somewhere between the two primary colors from which it is made. The relationships go on and on. Studying the color wheel can help you get a better feel for colors and how they affect one another.

Of all the colors you can place with red, blue would offer the greatest contrast, in large part due to blue being one of the colors that recedes the most. Blue is the infinite sky. It is a cool color, able to calm and nurture. It's refreshing, soft, safe, and dependable. It is sensitive and peaceful. Blue sheets "feel" cooler on a hot summer day than do tan, apricot, or lemon yellow sheets. Yellow is light. It is playful, creative, and warm. It can also represent cowardliness and illness. It is, like red, a color that advances.

Orange has the distinction of being the only color that shares its name with a fruit, and because of this, the color orange soon became associated with fruitfulness. It is fire and flames; it is warmth, it is the sun, it is lust, health, vigor, excitement, and adventure. Orange results from the blending of red and yellow; a perfect fifty/fifty blending results in a "perfect" orange. Orange, like red and yellow, is also a color that advances.

Green, the most dominant color in nature, is surprisingly not a color necessarily associated with harmony and balance; it is a symbol of hope and recovery, and of freshness and renewal. Think of the many green buds of the trees following the harshness of winter. It's a symbol of fertility, as exemplified by the many brides who wore green during the Elizabethan era. It's a symbol of growth as well as abundance. It's also the color of aliens, envy, seasickness, and phlegm. Green results from the blending of yellow and blue. Like blue, it recedes.

Violet, or purple, is symbolic of royalty and Christianity (think of the purple robes of kings, queens, and priests). It commands respect, signifies wealth, implies leadership, and connotes spirituality. The origin of purple as a dye goes back to ancient Greek times when a species of mollusk was found to yield—through an elaborate and expensive process—a dye subsequently called Tyrian purple, which was so expensive only the wealthiest could afford it. A blending of red and blue, violet is also a recessive color, even more so than blue and green.

So, where does one begin to look for color? Many outdoor photography enthusiasts will head for the mountains, deserts, beaches, or flower meadows, while a few others start their search on city streets, in alleyways, and even in auto wrecking yards. Regardless of where your search takes you, make it your goal to shoot compositions that first and foremost say *color*, as opposed to landscape, flower, portrait, or building. I

often suggest to my students that wherever they choose to search for color, they begin to do so with the aid of a tele-macro lens. I'm a big fan of the Nikkor 70–180mm micro lens, but any tele-macro lens (or moderate telephoto with a macro feature or telephoto used with extension tubes) will do the trick.

It has been my experience that narrowing your search to the much smaller "macro" world will, in fact, result in a much higher success rate. Almost without fail, many of my students who do this soon discover that they're seeing color possibilities not just with their close-up equipment, but also with their long telephotos and their wide-angle zoom lenses. One student's remark following several days of shooting color with her macro lens probably best sums up the feelings of most, "I feel like Lazarus. The discovery of color has awakened me!"

As I said earlier, color is so obvious, and just like the air we breathe, it's everywhere. A path toward creative image making benefits from a much higher awareness of the color that surrounds you.

You don't have to go far to find the color green. It is most dominant in the spring and summer in both agriculture and nature; it is rarely found in the man-made world. Following an evening of rain, I awoke to a morning of clear skies, simply headed out my front door with my camera and Micro Nikkor 105mm lens, dropped to my belly, and was soon immersed in a multitude of green lines—the dew-laden stems of the grass in my own front yard.

[105mm lens, 1/125 sec. at f/11]

W here would the world be without flowers? For close-up photographers, it would spell nothing short of doom and gloom. Of all the flowers the amateur photographer chooses to shoot, none is more favored than the rose. When the rose just begins to open, one can find truly sensual compositions, so several days after giving my wife roses, I paid special attention to their opening buds. With my camera and Micro Nikkor 70–180mm lens on a tripod, I moved in closer until I had filled the entire frame with the vibrant red color and curvilinear lines.

[70–180mm lens, 1/15 sec. at f/11]

I 've said it often, and as long as I've got students to teach, I'll probably continue saying it: "First and foremost, make it an obvious picture of color!" Rather than looking for rocks, leaves, trees, waterfalls, birds, flowers, fire hydrants, starfish, boats, orchards, or bridges, focus your energy and vision on red, blue, yellow, orange, green, or violet. Color *first,* content *second!*

Color is everywhere— including this graphic abstract image of, simply, a holey section of blue hamburger stand in front of a red car. With my camera and lens on a tripod, I chose a viewpoint that kept the camera parallel to the subject.

[70–180mm lens, 1/30 sec. at f/11]

I can't imagine anyone making a visit to the small island of Burano, Italy, and not coming away with shots of vivid color. It's apparent within minutes of disembarking from the ferryboat that the people of Burano love color. Over the years, I've been captivated by a host of different subjects and shot numerous rolls of film as a result, but Burano is the current record holder for me. At the end of my three-day stay, I had shot exactly 117 rolls of film!

I made this image when I turned the corner of one small street and heard the sound of children's laughter. Several hundred feet ahead, two boys were playing with a soccer ball in front of the most colorful house in all of Burano. Although this was in a very narrow alleyway, by using my 17–35mm lens I was able to create a composition with the house and the two boys playing in front. With the camera and lens mounted on a tripod, I chose an action-stopping shutter speed of 1/250 sec.

[17–35mm lens at 20mm, 1/250 sec. at f/4]

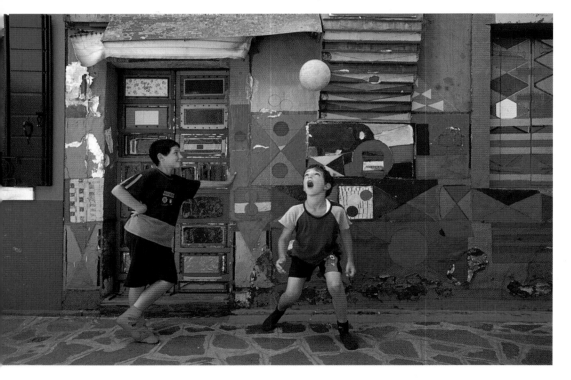

My daughter Sophie is not fond of honey-bees, unless they're part of a story about Winnie-the-Pooh. Despite my repeated assurances that the bees were too busy making honey to bother her, she refused to stand still in this meadow of lavender so that I could take her portrait. Always keep that finger on the "trigger" as you never know what may happen next. As she ran down the row, heading for the safety of the nearby car, I managed to record but one successful image—and I personally love it! (*Note:* The other four exposures that I fired off were either a bit out of focus or the composition was a bit off.) If I had made this same image in a field of red tulips, white daisies, or yellow daffodils, would it have been as successful? Probably not. Due to purple's strong associations with royalty, this little princess is right at home, despite her many protests to the contrary.

[80–200mm lens at 200mm, 1/1000 sec. at f/5.6]

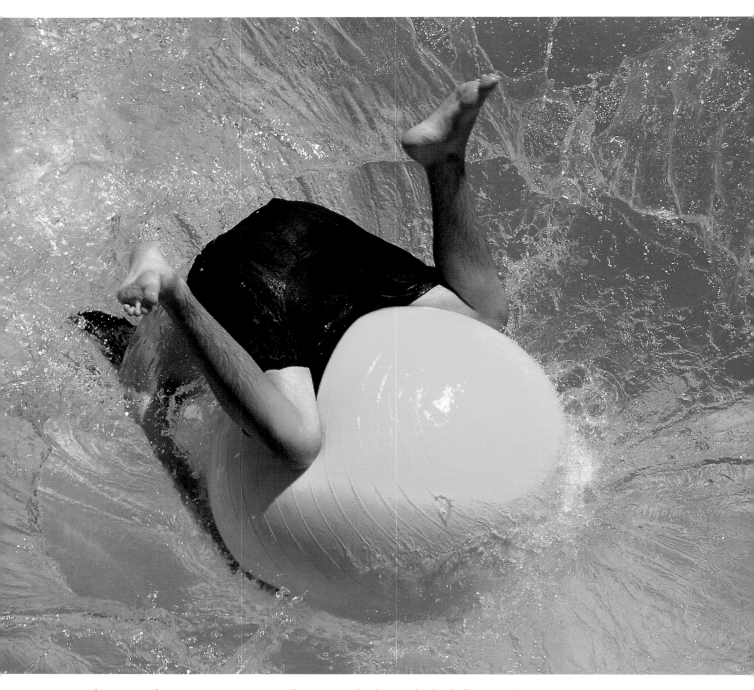

Colors can make a splash—literally! The contrast of the yellow ball (an advancing color) against the blue water (a receding color) serves to strengthen the feeling of depth in this image.

Asking one the neighborhood kids to "model" for me was a relatively easy proposition considering it involved swimming in the pool. Standing atop a twelve-foot stepladder enabled me to shoot down into the pool. Holding my camera, I adjusted the settings. When I was ready, I yelled "Action!" and, as instructed, Danny launched into the pool with the bright yellow ball tucked under his belly. Over the course of the next thirty minutes, Danny repeated this scenario for me a number of times—108 to be exact! I got a number of winners, and this was one of my favorite exposures.

[35–70mm lens at 50mm, 1/500 sec. at f/8]

While conducting a photo workshop in Singapore, one of my students walked toward me with a wide and precocious smile. She looked like the cat who had just eaten the canary. When she approached me, she exclaimed that she had found a most compelling subject and wanted to see how I would photograph it. Once we had walked back up the road, I was quick to understand her elation. She had discovered a wonderful location with the primary colors blue and yellow, and a lone black chair. I was so taken by the simplicity of the arrangement that I had already shot two rolls when my student remarked, "How much film are you planning to use on this?"

I started to laugh because I had been shooting at such a fast and furious pace, yet the arrangement was not about to disappear, and there was no fear of losing the light since the entire scene was under the open shade of the overhanging porch. I could have easily afforded to take it slow, but this is often my response to images that move me.

[35–70mm lens, 1/60 sec. at f/11]

Clearly paying attention to color and its emotional messages is an important step toward developing photographic maturity. Likewise, so is paying attention to monochromatic color images. These are simply images comprised of shades of just one hue (color), or images devoid of any colors and just comprised of black, white, and shades of gray. The winter season is the most likely time for finding monochromatic images of the latter type, although I've shot a few in the summer—for example, two empty white rocking chairs on a gray porch against a white house.

To record monochromatic images of winter snow scenes, you *must* plan on doing so on overcast days or while the snow is falling, and choose subjects that are stark, dark shapes. That red barn you photographed last summer will never record as a monochromatic image on color film in the snow, no matter how overcast a day it is—but it will certainly make for a wonderful image of great contrast, with vivid red against all that white. Instead, choose something like these three windmills, which I came upon in West Friesland, Holland, following several hours of snowfall.

[17–35mm lens, 1/30 sec. at f/16 for a +1 exposure]

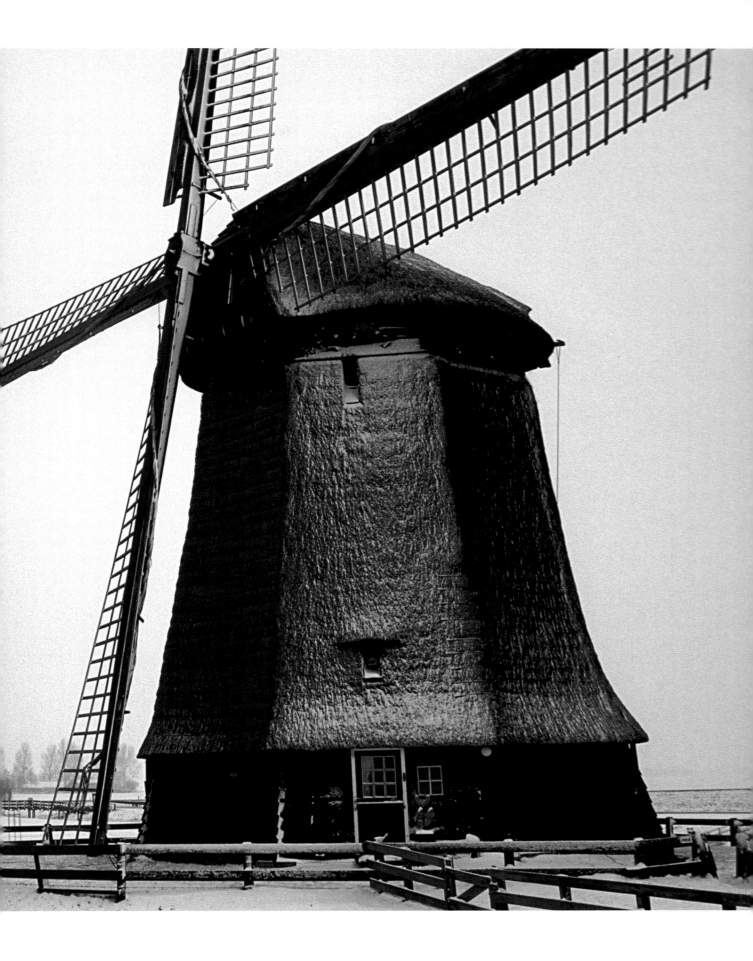

COMPOSITION

Filling the Frame

As a youngster, I often found myself taking things apart just to see how many parts there were. Some of my victims? A vacuum cleaner, a rusty lawnmower, a transistor radio. Putting it all back together was never the challenge for me, so on many occasions I would hear, "Bryan! Get out there and clean up that mess you made in the garage!" Model cars and airplanes were a different story, however. I got so excited knowing that I was about to open a box of many, many loose parts, and that with a tube of glue and a small bottle of paint or two, I was going to assemble these parts into a real "live" car or plane. But neither cars nor airplanes compared to assembling those battleships! My brother and I once spent more than three weeks working on one, ever mindful of the minute details that go into building a ship.

Photographically speaking, there are two kinds of compositions: those like the mess I left behind on the garage floor—you can see all the parts and perhaps figure out what whole they came from; and those like the battleship—everything in its place, leaving no doubt as to what it is. It's fair to say that all photographers strive toward the "battleship" composition, and achieving that aim is often an internal *battle:* How is my point of view? Should I get down low? Should I go higher? Should I use the telephoto or the wide-angle? Is this a good background choice? Should I shoot at a small aperture? Is my shutter speed slow enough? Should I come back when the light is better? Would I be better off using my tripod? Should I add a filter? Damn wind! Damn cloud! Damn rain! Damn car! Damn power line! Despite this, what is the biggest compositional flaw that plagues most amateur photographers? The failure to *fill the frame!*

With all of the lawnmower parts spread out all over the garage floor, for example, it's difficult, at best, to figure out exactly what the subject is. The most obvious solution, and by far the easiest, is to simply take a step or two closer to the subject. In effect, sweeping all of the lawnmower parts into a central area. If walking closer to your subject is out of the question—perhaps your subject is a moose grazing in a meadow on the other side of the river—then you must resort to filling the frame by using a longer telephoto lens. And yet, even after photographing the moose with the longer lens, don't be surprised if the final result is not close enough. Why? Because your brain tricked you into believing that you did fill the frame. This trickery is, for some, a difficult hurdle to overcome.

Simply put, your brain is constantly blowing things out of proportion, especially when you look through the viewfinder. Your brain will make a very selective "image magnification," deliberately sorting out the surrounding clutter. This very quick "read" allows you to identify and know what it is you're looking at, in effect "seducing" you into seeing *only* the moose. Interestingly enough, it is your brain's ability to "filter out" this visual clutter that keeps you from going nuts.

Let me explain. Throughout the day and into the night, our vision and our hearing are exposed to and bombarded with literally thousands of sights and sounds. Rather than go crazy from this onslaught, our brain has this magical ability to filter out much of the "noise" that surrounds us, allowing us to concentrate on driving the car or to converse with others in a crowded mall or to eat and read the newspaper in a hectic restaurant, and so on. You can be eating and reading your paper and completely miss the hot stock tip being discussed at the table next to you. And, you can be so focused on that moose you have in the viewfinder that you fail to see that its hind legs merge with several branches of a nearby tree, or that it is really not taking up as much space in the frame as you think it is. Let me add just one final comment about filling the frame: You can't carve a turkey if you're standing three feet from the counter! Get close.

Outdoor flower markets (this one was in Amsterdam) are great places to hone your compositional skills, especially the art of filling the frame. On this outing, I proceeded to fill my frame with a pattern of tulips—or so I thought. Yikes! Look at the "clutter" around the edges of the first photograph (opposite). Not until I moved in closer (above) did I match up my brain's vision with that of the viewfinder.

[Opposite and above: 35–70mm lens at 35mm, 1/60 sec. at f/11]

Cropping In-Camera

Everything—and I do mean everything—in your viewfinder that is within the plane of focus will record on film *exactly* as you frame it, and that includes *all* the "clutter" above, below, to the left, and to the right of the subject. And, everything else that is not within the plane of focus could conceivably interfere in your composition if you use the wrong aperture. Since aperture controls depth of field, the area of sharpness may increase behind and in front of your subject.

So, before pressing that shutter release, inspect your viewfinder top edge to bottom edge, right edge to left edge. (If you're using small lens openings—*f*/11, *f*/16, *f*/22—depress your depth-of-field preview button and then inspect the viewfinder.) Then close your eyes for a few seconds, picturing in your mind what you believe to be true, and open them again and look in the viewfinder to see if, in fact, this same image is in the viewfinder. There's no better time to crop a bad composition than just *before* you press the shutter release. Photo software programs can do this for you of course, but *after* the fact. Don't you value your time more than that? Make it a point to crop in the viewfinder. As the saying goes, there's no better time than the present.

On a recent photo assignment, I came upon this small lizard at Busch Gardens in Tampa Bay, Florida. With my camera and 70–180mm lens mounted on a tripod, I was quick to zoom to the 180mm focal length and fill the frame. But, as the first attempt above shows, I actually hardly filled it. It's a composition that leaves the viewer wishing to see more. I couldn't bring the lizard any closer by zooming the lens since the lens was already set to 180mm; I had but one option, which is oftentimes the most obvious and easiest solution to filling the frame: walking closer to the subject. As I did this, I made sure my steps were, of course, slow and gentle, also making a point to keep one eye on the viewfinder to determine when I was close enough. In the closer version (right), the lizard fills the frame in a way that satisfies the viewer's curiosity and desire to see the lizard up close.

[Both photos: 70–180mm lens at 180mm, 1/250 sec. at f/5.6]

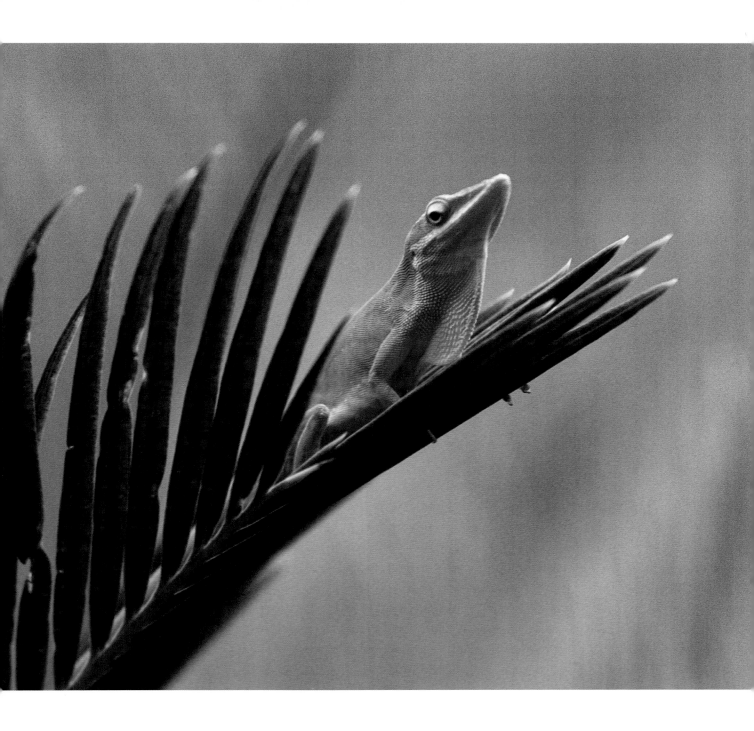

The Golden Section and the Rule of Thirds

Since the human mind seeks order, its response to chaos is one of immediate alarm and then the attempt to impose order onto the disorder. Take, for example, the aftermath of a tornado, which is one of destruction and often death. Returning to the scene from the safety of their basements, people begin to assess the situation, looking for *shapes, colors, lines, and identifiable patterns* to help them determine the extent of the damage. Within minutes, the mind is soon making order—borders are defined: "We've got a two-block-wide path of destruction that extends about a half a mile," for example. This process of the mind is completely involuntary and almost instantaneous.

Whether it be a tornado or something as simple as assembling the parts of a model airplane, the mind will do everything it can to make order out of chaos. In order to feel safe, the mind needs order. This need for order extends to art, as well. At its core, every successful painting is due to an orderly and cohesive composition and pattern. To better express order and what they felt were compositional ideals, the ancient Greeks devised a proportion guideline that is still being used today: the Golden Section. This referred to a rectangle with longer sides that were roughly two thirds greater than the shorter sides, for example a 5 x 8-inch rectangle. This proportion became the standard for much of their architecture, as well.

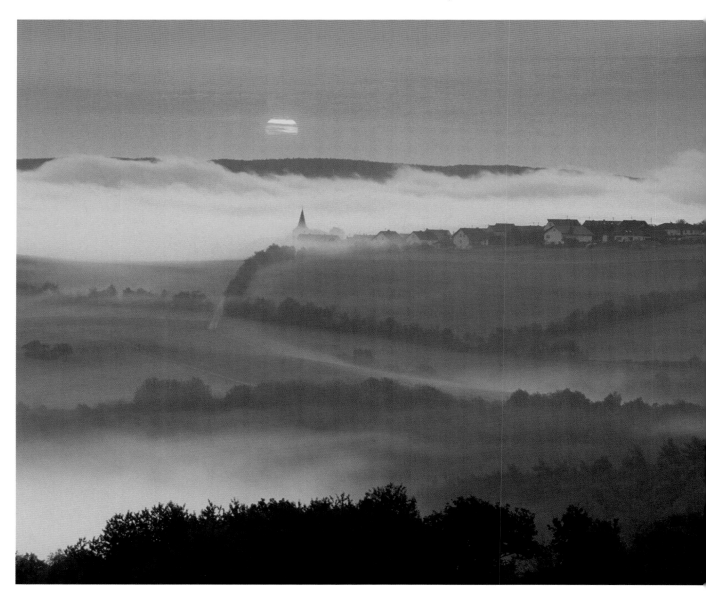

Soon, artists were realizing the eye's preference for threes and were laying an imaginary grid of two evenly spaced horizontal and vertical lines over this ideal rectangle, dividing the shape into nine equal sections also of the same ideal proportions. This imaginary grid became known as the Rule of Thirds, and artists would use it to help determine optimum subject placement. They realized that how they placed important compositional elements with respect to these lines and their intersecting points determined the success of an image. Placing important elements along these third markers often improved things substantially. The fact that this system is still in use today in all of the graphic arts is proof of its veracity.

The Rule of Thirds is used in photographic composition as well as in painting, or other more traditional mediums, because composition is just as important in photography as it is in painting. To use it, when you look through your viewfinder divide the frame into thirds, both horizontally and vertically, and picture this imaginary grid over the image as you compose.

For years now, I've wondered why no camera manufacturer has yet made a viewfinder that offers a grid of thirds. I find it simply amazing that today's cameras offer *auto* everything but still no auto-composition via a grid in the viewfinder! Granted, the grid is not capable of searching out unique and never-before-seen images; that will always be the photographer's job. But, I can only imagine how many beginners and even intermediate photographers would benefit from just such a grid. Nikon, Canon, Minolta, and Pentax do offer grid-screen options, but these grids are comprised of *four* horizontal lines and sometimes *five* vertical lines—that's no grid, that's a chess board! Other than helping photographers keep horizon lines straight, these grids really serve no useful purpose.

Racing against the sunrise clock, I finally reached the top of the countryside above the Rhine River in Germany. I quickly turned off the main road and onto a small one-lane road. When I found this spot, I hurriedly set up my camera and lens on a tripod and framed this sunrise scene. As you can see by my placement of the grid of thirds, I felt the interest was greatest below the horizon and so I allotted two thirds of the image to the land and one third to the sky.

[75–300mm lens at 300mm, 1/60 sec. at f/16]

Just like the Flemish and Dutch painters, I love to capture the drama of the sky. On an outing in the south of France, the sky had been conducting a wonderful symphony of lightning and thunder. I followed the storm east to west—finally stopping when I came upon this large field of sunflowers—and waited for a small opening between the clouds that would let some early morning sunlight down onto the field below. Since my interest in this scene had shifted to what was above the horizon line, I placed the horizon near the bottom third of the composition by tilting my tripod and camera a bit upward.

[80–400mm lens, 1/60 sec. at f/22]

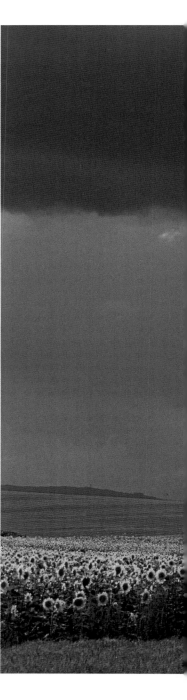

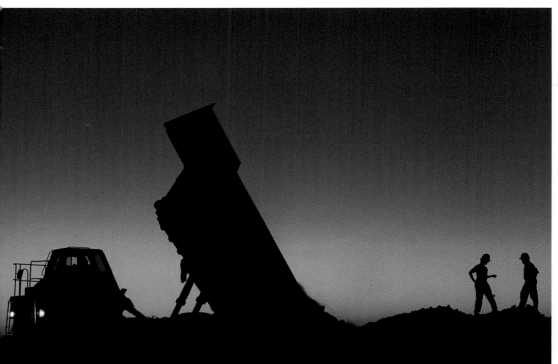

While on an assignment for a corporate annual report in Nevada, I made this image following sunset. As are many of the images made for a corporate annual report, this photograph was staged; once everything was in place, I simply mounted my camera and lens on a tripod. Clearly, this is another composition emphasizing the sky. Any time you emphasize the vast sky like this, you create a feeling of humility in the landscape below.

[80–200mm lens at 100mm, 1/15 sec. at f/11]

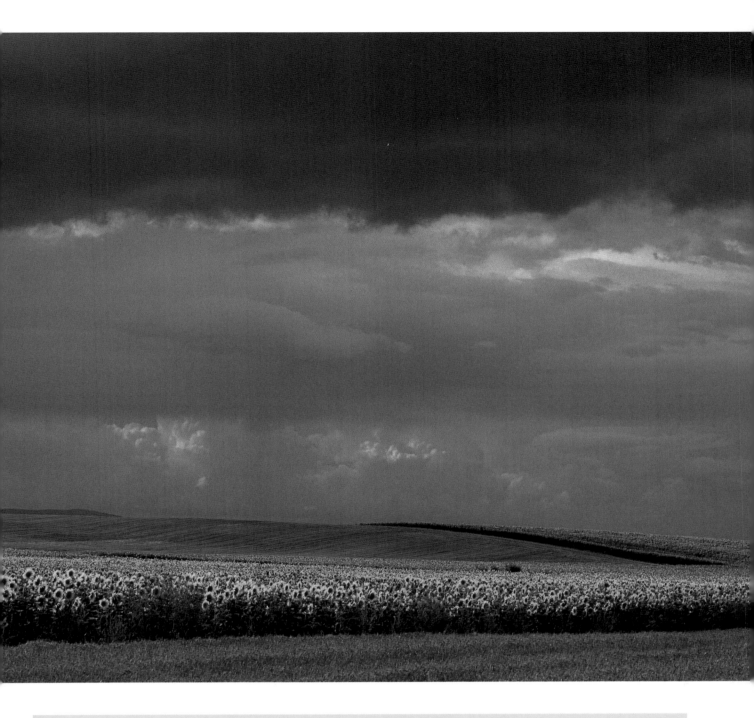

Odd Numbers and a Preference for Three

Did you know that most people are more comfortable with odd numbers than with even ones? At the craps tables in Las Vegas, lucky seven or lucky eleven are the numbers of choice. And among odd numbers, the favorite is the number three. Think of the Three Musketeers, Three Blind Mice, the Three Stooges, and the Three Little Pigs. There are three Charlie's Angels; three Power Puff Girls; and Huey, Dewey, and Louie (Donald Duck's nephews). Lest we forget, the third time's a charm, and three strikes and you're out. The eye also tends to prefer compositions influenced by threes—a point proven by the continuing influence of the Rule of Thirds.

50/50 vs. 66/33

lthough every image or idea begins with a degree of uncertainty, there is one constant: Rarely does a composition succeed if the space and elements in a scene are divided equally in half. By splitting the frame into two equal parts—for example, with the horizon line—you run the risk of recording a composition that is undefined and, subsequently, indecisive.

When objects and subjects are treated equally, they often—although not always—cancel one another out.

In the sports world, for example, games rarely end in ties; there are extra innings, overtime periods, and "sudden death" extra plays to determine a winner. In the political arena, as people in America have recently witnessed, a presidential election cannot end in a tie either. Similarly, in photographic composition the eye demands that a clear "winner"—one element in the frame that clearly has more importance than the others—be conveyed. Breaking up the space within the frame into any combination of thirds helps the photographer do this.

As photographers, our choices are many. To determine the most important element in a composition, ask yourself a few questions. What is this picture going to be about? What should I include or exclude? Is the emphasis going to be above or below the horizon line? Will the main subject be in the left third or right third? And, how should it finally be arranged?

In the image opposite, the composition suffers from a "tie." The horizon line divides the photograph equally in half, and the largest tree falls close to dead center in the frame—it's a dreaded fifty/fifty split both top to bottom and side to side. The solution for fixing this is easy: Simply moving the camera to the right and tilting it up just slightly divides the space more into thirds than halves and results in a more compelling composition (right).

[All photos: 17–35mm lens, 1/15 sec. at f/22]

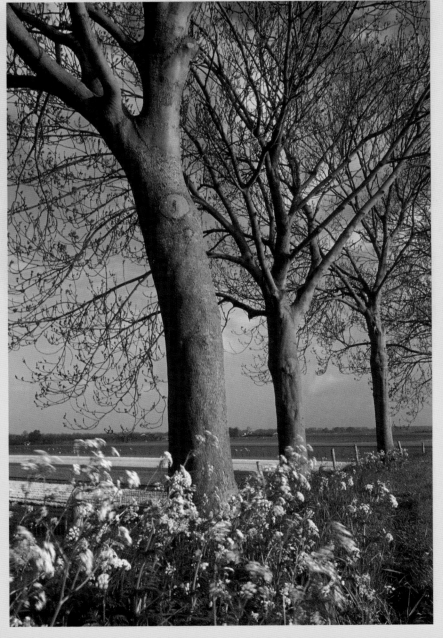

No Horizon

The challenge of successful composition would be a relatively easy one if the subjects were limited to landscapes. But, most of us have chosen to extend our range of subject matter far beyond the landscape and, subsequently, will need to meet the challenge of creating the perfect composition even when no horizon lines are present. For some photographers, trying to compose without horizon lines is tantamount to driving blindfolded, yet the solution is rather easy.

Most hobby and craft shops carry plastic laminating kits designed to protect small photographs or driver's

Why would you ever *not* want to include a horizon line when photographing a landscape? For some photographers, the mere idea goes against everything they've learned, studied, and applied. How can it be a landscape without the sky? This example of my wife in a sunflower field answers that. By elevating my vantage point, I was able to develop a strong and graphic composition.

The first image (above), although nice, suffers from the inclusion of the sky. I'm not against using the sky in my images, and there are many in this book that do; but when the sky serves as an exit point, leading the eye out of the photograph—as it does here—it should be eliminated from the frame.

To get the elevation necessary to exclude the sky, I stood on a ladder (my wife was also on a ladder to get her above the tall flowers). By limiting the emphasis of the photo to one subject (by excluding the sky), I contained the eye within the picture borders, and it doesn't wander away from the subject—at least, not for long, as the eye is "forced" to come back to Kathy (right).

In addition to a ladder, a bucket truck is another good tool to get height. For $300, I've rented a bucket truck that allowed me to go as high as sixty feet. Is it *always* necessary to use a bucket truck to achieve simple compositions? Definitely not, but certainly an elevated position will often help.

[Both photos: 35–70mm lens, 1/125 sec. at f/16]

licenses and the like by simply laminating pieces of plastic adhesive to both sides of the item. What I suggest to my students is to laminate the two pieces of plastic adhesive together *without* anything between them. Then, with a felt tip permanent marker (preferably black) draw two evenly spaced horizontal and vertical lines on this to create the Rule of Thirds grid. You now have a very useful wallet-sized tool that you can begin using right away.

Look through the grid at just about any subject—from close-ups to portraits, distant buildings, or something abstract—to determine what is the most harmonious composition. (The lens you'll be using will, of course, determine at what distance you hold the card from your eye.) In a manner of months, after looking at all of your subjects through the grid, you'll discover that you no longer need the card—even when there are no horizon lines present.

The Right Third

The Rule of Thirds formula applies to subject placement not only for landscapes but for portraits as well. It's also important to note that whether it's a portrait of a steel worker, a combine in a wheat field, or a window flower box, the image usually looks better and is more successful when the primary subjects are in the right third of the composition. It's *almost* a psychological "law."

Certainly, the two thirds/one third division produces the most harmonious results, but why is there this preference for placing the primary subject in the right third? It's natural for the eye to "enter" a space from the left and flow to the right. This is not only true when you look at photographs, but also when you view paintings, read, or even enter a room. And, soon after entering the frame from the left, the eye searches out a resting place, preferring it to be on the right most of the time.

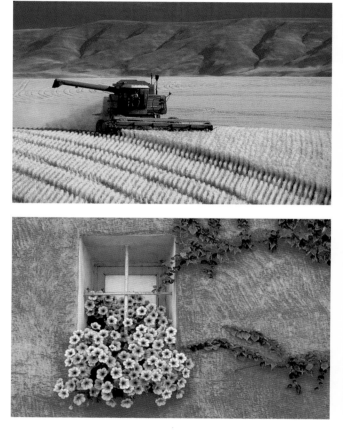

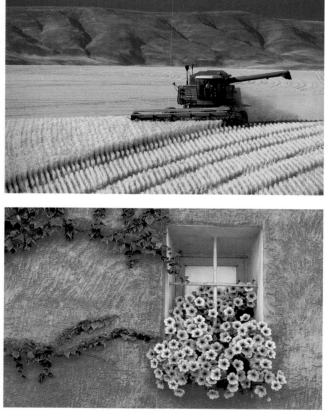

Compare the two pairs of photographs on this page. How do you feel when the primary subject is in the left third? It is, no doubt, uncomfortable. It just doesn't feel right.

[Both photos, above: 300mm lens, 1/60 sec. at f/16. Both photos, below: 80–200mm lens at 80mm, 1/30 sec. at f/11]

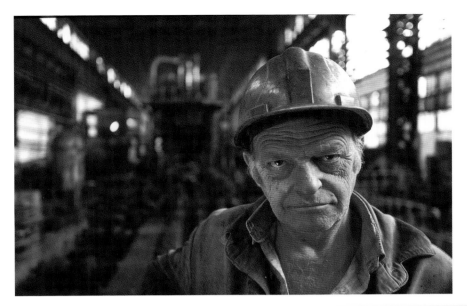

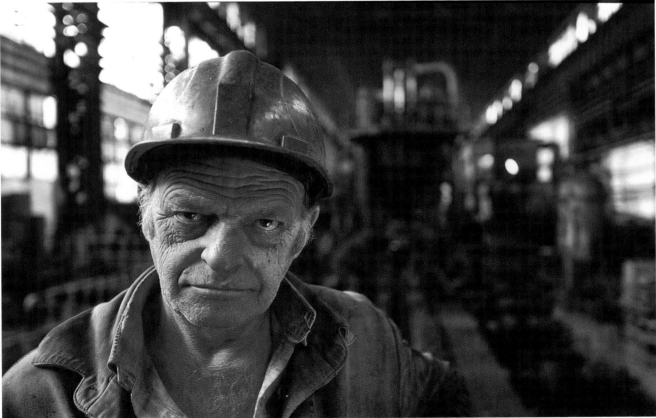

Just when you think compositional "rules" make sense, you come upon an image that defies the logic of placing your subjects on the right. This Unkrainian steel worker just doesn't work anywhere else in the frame except in the *left* third. Why? Because of the power of line. The converging background lines pull at the eye yet still return it to the stable portrait. This creates an exciting tension. When the image is flipped to show the steel worker on the right, something seems off. There is a feeling of "dead" space on the left that begs to be cropped out. Additionally, when you step into the frame, your eye is swept away by the pull of the lines on the left and it tries to hang on to the figure, which feels awkward. When the dead space is on the right, you don't experience it in the same way because your eye moves to the right and is then thrown back up front to the figure, meeting him again eye to eye. (See page 28 for another example of a successful subject on the left.)

[17–35mm lens at 20mm, 1/8 sec. at f/2.8]

Diagonals

Every line evokes an emotional response, and that is certainly true when we talk about the diagonal line. The sense of movement, activity, and speed that the diagonal line evokes can often breathe life into an otherwise static composition. Sometimes, the photographer makes a deliberate decision to photograph a composition with the camera turned on a diagonal, but there are many, many natural diagonals to be found if you just take a look. Again, the Rule of Thirds is alive and well; it is the base upon which layers can be added, keeping in mind that these layers adhere to the same one third/two thirds principle.

Mount Shuksan, in Washington State's Mount Baker National Forest, is just another volcano on most days, but not this one. The passing storm clouds around the mountain created two converging diagonal lines. The result was a feeling of movement and activity, which was appropriate because the storm was far from over. To get this image, I was quick to mount my camera and lens on a tripod during a short break in the passing storm. Although the moment lasted a mere thirty seconds, it was enough time for me to fire off several frames.

[300mm lens, 1/15 sec. at f/8 for a +1 exposure]

At a bird market in Singapore, I saw this one bird cage partly covered by well-weathered newspaper. With my camera and 80–200mm lens on a tripod, I set the focal length to approximately 180mm. Although I felt this was the right focal length to achieve the composition I was seeking, I was not at all happy with the gray concrete wall that formed the background behind the birds. So, I had my assistant hold a piece of colored fabric about three feet behind the cage, and I knew immediately that this colored, out-of-focus tone was exactly what I needed to separate the birds from the dull, dark gray background. This contrast between the pink background and the newspaper lets the converging diagonal lines formed by the paper, and their suggestion of activity, become the focus.

[80–200mm lens at 180mm, 1/250 sec. at f/8]

Now that the house was finished, we were all excited to move in. My dad, mom, four brothers, and one sister had been waiting in earnest for this monumental day. The promise of my very own bedroom was something that even I, as a five-year-old, could appreciate. A week following the move, we were all enjoying a Saturday dinner of homemade pizza in our new dining room with, as my mother was fond of saying, "the most beautiful picture window I've ever seen." To a five-year-old, "picture window" has a different meaning, as I found out several days later. While my mother was busy unpacking the remaining boxes, I was busy finger-painting the most beautiful picture window. You can imagine my shock and surprise when my mother entered the dining room and exclaimed, "My God, Bryan, what have you done!?" I'll leave it to every parent to imagine what followed, but suffice it to say, I learned that a picture window was not something you drew pictures on.

A picture window is really no different from the camera viewfinder in that they both can frame a compelling subject. If a house is designed well, its picture window will frame a picturesque view of the outside landscape, and if you point your camera in the right direction you, too, will frame a compelling subject. One of the surefire ways to make an image more appealing is to introduce foreground subject matter to call attention to, and frame, the main subject in the background. This technique is often referred to as a *frame within a frame* or *framing with a frame.*

To do this successfully, you can't use a foreground subject/frame that distracts the eye. Additionally, you should ask yourself the following: If I remove the foreground subject, would I miss it? And, will the frame enhance the overall composition? If the answer is "no"—if, for example, the foreground frame dominates the composition or is more of a distraction than a complement—then the framing is not successful.

In Oregon's Hood River Valley, springtime is welcome following normally harsh winters of ice and snowstorms. The apple and pear trees celebrate every April by donning their costumes of pink and white flowers. Finding one such apple orchard allowed me, by carefully choosing my point of view, to frame the distant Mount Hood using foreground tree branches. One of the greatest clichés in landscape photography is the scene viewed through overhanging branches, but while it may be hackneyed, it is still effective. Framing the image this way limits the field of view and calls attention to the subject. This is also one of the easiest ways to create perspective since it always brings a sense of depth to a composition. You can easily frame an image with a telephoto lens by focusing past the foreground on the background, thereby throwing the foreground out of focus and directing the viewer's attention beyond to the focused object, which is farther away from the camera. Of course, the foreground frame does not have to be out of focus; you may decide to also render everything in the scene, from front to back, in exacting sharpness.

[105mm lens, 1/30 sec. at f/32]

There's probably no better example of a picture window than in Arches National Park in Utah. I, like so many other photographers before me, took the trek to Window Arch, arriving at dawn to shoot the obvious frame-within-a-frame composition (left).

When I attempted to shoot a vertical version of the same subject (above), I was still able to achieve the frame-within-a-frame effect, but it is not nearly as compelling. By trying to compose this same scene as a vertical, I introduced the sky as another element and this gives the eye a chance to "escape" out the top of the image—and that's the last thing you want to have happen with any composition. Effective and successful composition relies heavily on the idea of containment. It makes perfect sense to pour milk in a glass—it is, then, contained; unfortunately, many compositions taken by amateurs look like milk that has been poured on a table—scattered.

[Both photos: 35–70mm lens at 35mm, 1/60 sec. at f/16]

A Note about
Picture Edges

I have witnessed countless photographers suffering from "tunnel vision." When composing, all of their focus is toward the middle of the frame. They often forget about the need for boundaries to define the edges, and contain and complement the main subject. The lack of clearly defined edges in a photograph is tantamount to spilling a glass of milk on the table (as mentioned on the previous page). You've got to catch the milk before it runs off the edge. If you think of the eye/brain combination as spilled milk, you will soon realize the need to *contain the eye*—to hold its attention—and not let it run off the edges of an image. This attention to the edges of a photograph is one of the surest and shortest routes to creating successful imagery.

Perhaps not as obvious as the prior examples, this very happy Italian boy on the island of Burano, Italy, is also framed within the picture frame—in this case, by the colorful doorway surrounding him. The lines of the doorway box him in. This is an example of how framing within a frame can act as an exclamation point by further emphasizing the importance of the main subject. Handholding my camera, I made numerous exposures while his older brother, who was standing to my left, engaged him in a humorous conversation.

[35–70mm lens at 35mm, 1/125 sec. at f/8]

Horizontal vs. Vertical

Due to camera design, it's only natural that most of us end up shooting all of our subjects inside a horizontal frame. It's a sad fact that, on average, 90 percent of the amateur photographer's pictures are horizontal. Just how serious is this problem? I had a student ask me once if it was worth the money to buy a camera that shot vertical compositions. Yikes! That's a sad commentary about some of the help that stands behind those counters at the local camera store.

So, why would you ever want to shoot verticals? To bring a feeling of dignity to the subject, that's why! Such are the emotions evoked by the vertical line; it conveys strength and power. However, since we favor the horizontal, photographers manage to squash, squeeze, and push down the obvious vertical subject in order to make it fit inside the horizontal frame. The biggest danger in doing this, of course, is that you have to back away farther from the subject to make it fit inside the horizontal picture frame. And even though you made it "fit," you are now left with "clutter openings" on both the right and left sides of the frame. The easiest solution is to *turn* the camera to its vertical position. Voilà, the clutter is gone!

I'm often asked what time is the best to shoot a vertical. My answer often is, "Right after the horizontal!" Not all of the time—but most of the time—you can compose each and every subject in either the horizontal or vertical format. It may take some moving around, shifting your point of view, moving closer or backing up, or even changing a lens. But, the benefits of shooting your subject in both formats are obvious.

The biggest benefit is that you won't see a loss in image quality; when you end up cropping a horizontal into a vertical on your computer, there is always a loss in image quality. If you make it a point to crop in-camera from now on, you'll spend less time on the computer afterward, giving you more time to shoot. Additionally, should the day come when you're ready to take your work to the marketplace, you'll be more than ready: Should a client express interest in one of your horizontals and then ask if it is available in the vertical format, you can meet the demand and, thirty days later, deposit that check for your first magazine cover!

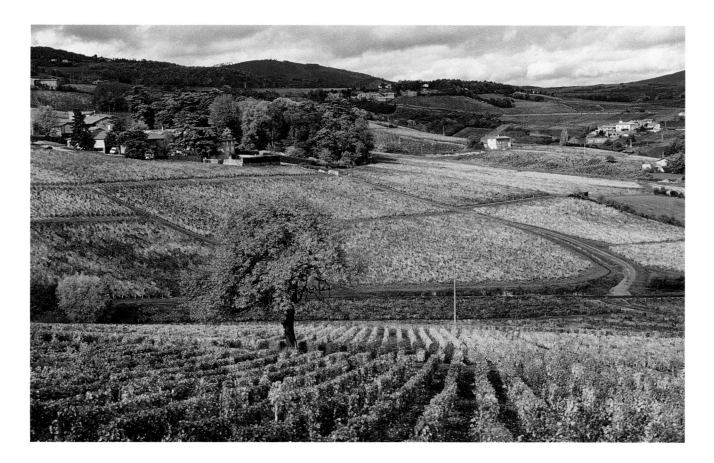

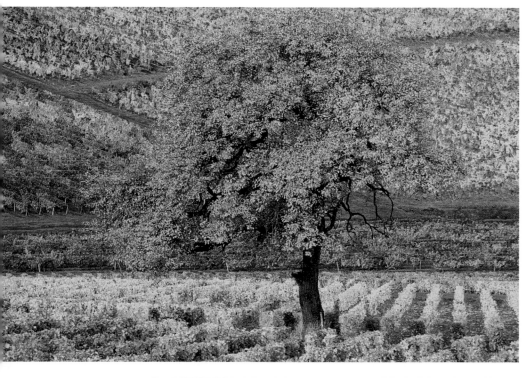

When I came upon this lone tree among the many vineyards in the French wine region of Beaujolais one autumn, I was quick to pull my car off the side of the road and set up my tripod and camera. I then walked up a small hill behind me to seek a higher point of view so that the tree would not break the horizon line. I first framed the tree within the horizontal frame with an aperture of *f*/32 for maximum depth of field (opposite). I also made a version cropping out the sky in-camera (left). Then, ever-mindful of the need to shoot the vertical right after the horizontal, I loosened the tripod collar on the lens and positioned the camera vertically (below).

[All photos: 80–200mm lens, 1/15 sec. at *f*/32]

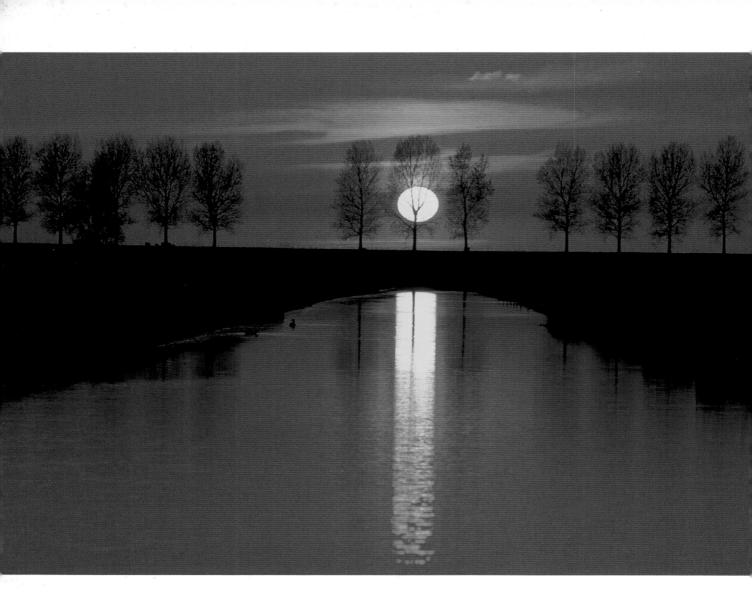

Along the many dikes in West Friesland, Holland, you will find numerous windbreaks to break the strong winds that blow in from the North Sea. Running through the many fields are the "poddlers" (streamlike flows of water for controlling flooding). Having already scouted the location earlier, I was all set up with my camera on a tripod as the sun began to set. With my aperture set to f/32, I adjusted my shutter speed until 1/60 sec. indicated a correct exposure while pointing the camera at the sky to the left of the sun. I then composed the scene and shot both several horizontal and vertical compositions.

[Both photos: 300mm lens, 1/60 sec. at f/32]

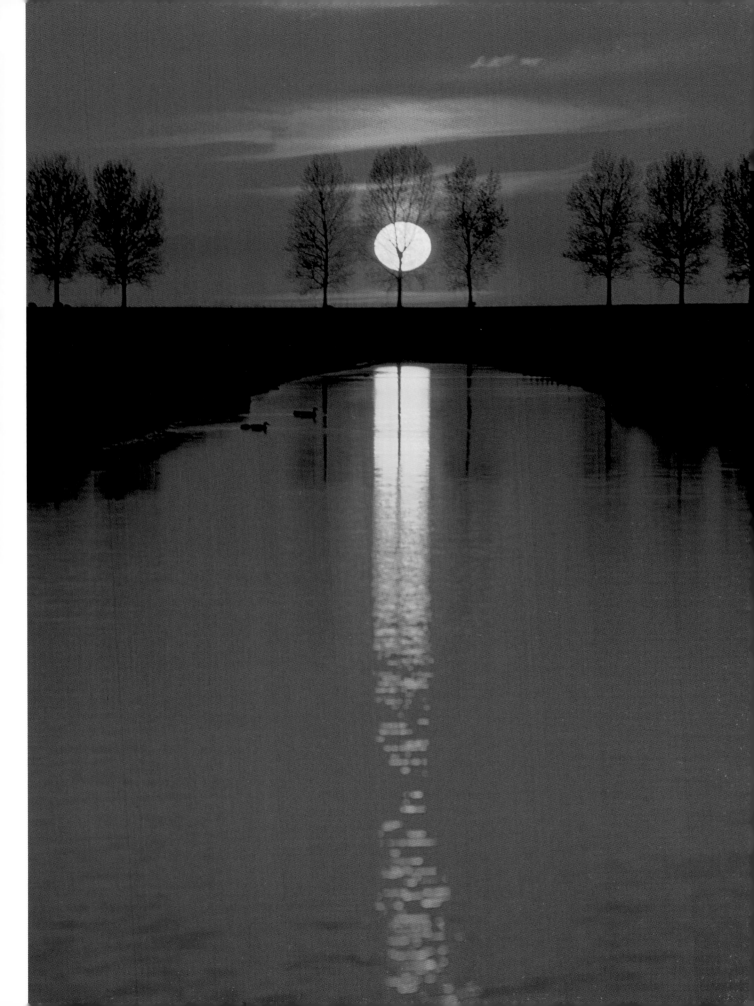

Picture Within a Picture

I've seen the following scene repeated time and time again in *all* of my on-location photography workshops: A student comes upon a truly compelling image and, after making an equally compelling composition, invites me to take a look and asks, "So what do you think?" Of course I exclaim, "It's really nice!"—at which point the student smiles and begins to pack up his or her camera gear and move on.

It's at that point that I always exclaim, "Whoaaaa! You're not done yet!"

Almost without fail, every picture has, waiting inside of it, *another* picture! This is very important to realize and remember. If you're at all serious about increasing the number of striking images you make, staying with your subject longer provides you with a golden opportunity to do just that.

Photographing children, whether your own or not, can oftentimes be rewarding—especially when you meet the child at his or her eye level. With my camera on a tripod, I framed this little boy against a background of green grass, and in order to keep the background limited to an out-of-focus green tone, I set the aperture to f/5.6, thereby reducing the depth of field. Before moving on, I also noticed the hand of the boy's father in the upper right portion of the frame and knew almost immediately that it might make an even more compelling image. I shifted my viewpoint and moved in closer with the same lens, filling the frame with a composition that speaks volumes about safety and security.

[Both photos: 300mm lens, 1/250 sec. at f/5.6]

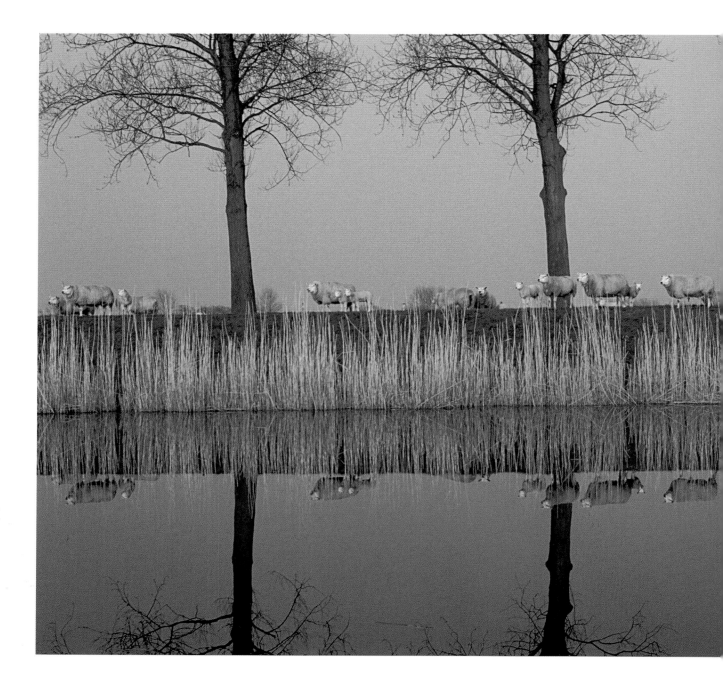

Coming upon these sheep atop a dike in West Friesland, Holland, I was quick to grab my camera and fire off several frames. My hurried pace was due to the fact that water like this—as smooth as glass—doesn't happen often in Holland; this little county is always doing battle with the often fierce weather from the North Sea. After shooting the perfect reflection (opposite), I thought, "Where's the next shot? There's something else here. I know there is." At about that same time, two small ducks landed in the water farther down the dike, disturbing the mirrorlike surface of the water, and I thought, "That's what I need!"

Rather than wait for the ducks to swim into my composition, I chose to set up a photograph that filled the frame with *only* the reflections of the trees, sheep, and dike (above). With the camera and lens on a tripod, I placed my right index finger on the shutter release and, with my left hand, tossed a small stone into the water. I waited just a few seconds for the ripples to fan out and took several exposures.

[Both photos: 35–70mm lens, 1/30 sec. at f/11]

Working Your Subject

D
o I find creating successful compositions easy? One might think that after thirty years of shooting, successful composition comes easy. At times it does, but more often than not I still find the need to "work" a given subject in much the same way that a sculptor chips away at a stone. I see the end result in my mind, but getting there requires me to "chip away." This chipping away may involve a change in point of view, in focal length, or in time of day. It may involve a simple change in exposure to limit or increase depth of field, or the use of a very slow or very fast shutter speed in order to achieve the desired effect. The need to look—to *really look*—for distractions in the background cannot be overstated. Also important is that willingness to break the rules, even if that means arranging and even rearranging subject matter *before* you make the photograph.

W
hile framing a lone window and potted palm plant, I remarked to my students how much I wished it were not a palm but rather a pot of colorful flowers. I then looked down the row of houses and spotted a pot of flowers on the front porch of a nearby house. I took it off the porch and placed it on the sill in place of the palm plant. The students appeared surprised but soon reasoned that exchanging one pot for another was no different from asking a person to pose in a certain way or to place them against a pleasing background. After I was done, I promptly returned the pot of flowers to its porch and also replaced the palm plant to its rightful place.

[Both photos: 80–200mm lens, 1/125 sec. at f/8]

When I announced to my students at the Maine Photographic Workshops that we were headed to a junkyard for macro photography studies, the groans could be heard all the way down to the Camden harbor. But following the "photofest" (as one student called it), everyone's earlier groans were replaced by a greater appreciation of the old adage that photographic opportunity is everywhere if you will only take the time to look.

At the junkyard, I came upon what I think was the rusted-out "drum" of a washing machine. I was originally drawn to it by its texture and shape. I also noticed several colorful objects nearby: red and blue pieces of metal and a yellow road sign. I was confident that these background colors would awaken the otherwise old and worn out drum. With my camera mounted on a tripod that was set low to the ground, I zoomed my lens out until I filled the frame with the circular shape at the bottom of the bucket. Several times, I had to get up and rearrange the background ever so slightly so that the out-of-focus colors would be uniformly dispersed across the patterned bottom of the drum. Once I had achieved this uniformity, I was ready to shoot. By working with the subject a little bit more, I was able to get the effect I was looking for.

Several of the students were surprised to see me manipulate the background in this way. It had never occurred to them that you could move objects in a scene in an effort to make a compelling image. One student who seemed most surprised said this was a rule she had been "taught" by her local camera club: that one must photograph compositions only in their *natural*

state—"Otherwise, it's not real." Quite a few years ago, I was asked to be a judge in a local camera club's monthly photo contest.

I still chuckle about the experience today. The very people who were professing this idea about shooting objects in their natural state were the

same people whose slides were often covered in part by a slide/crop mask to improve the composition. The message I got from all of this was that it was okay to crop your image with a slide mask when it clearly improved the overall composition, *but* you would have hell to pay if you ever moved your subject or cleaned up the area around your subject *before* you made your exposure. That made as much sense to me as putting a dirty diaper on a baby and then using masking tape around the edges to keep it from leaking.

If you're looking for permission to move objects into the frame or out of the frame or you wish to clean up your backgrounds or foregrounds, you not only have my blessing, but you will be made an honorary member in the Bryan Peterson Photo Club, where our motto is: The real *truth* of a photograph is in its ability to evoke emotion.

[Top: 20–35mm lens at 20mm, 1/30 sec. at f/22. Bottom: 70–180mm lens, 1/30 sec. at f/22]

With my camera and 70–180mm macro lens on a tripod, I framed this cluster of grapes in early morning frontlight. It was a gorgeous cluster to be sure, but I couldn't rid the background of the wooden post; even with the lens' aperture wide open, it was still apparent. The only way to get rid of the post was to cover it up. After tearing off five or six leaves, I took a roll of tape out of my gadget bag and taped these leaves to the post. Voilà! The post was gone.

I realize that in today's world, photographers have the option of using the Cloning tool in Photoshop for compositional problems such as this. Personally, I will always prefer making images *in the camera* rather than in the computer. It simply saves time. More often than not, most changes done in Photoshop by photographers today can and should be done in the camera. My chief concern about these imaging software programs is that they invite a "lazy" approach to the actual picture-taking process.

In 1979, I would have to wait twenty-four hours to get my Kodachrome film processed and then see the results of my picture-taking efforts—warts and all. By 1990, and with the color advances made in Ecktachrome-based slide films, my wait was only two hours to see the results of my picture-taking efforts—warts and all. All of this waiting taught me to be a patient observer, to pay really close attention to what was going on inside the viewfinder, and to invent means or methods that could solve the problem while I was *there* with the subject in front of me.

Today, when I use my Nikon D1X, I have no waiting time! I can see everything immediately on location—again, warts and all. Most of the digital photographers can now have instant confirmation of their skills or lack thereof if they have a digital camera with an LCD screen. If the instant results are disappointing, you have the opportunity to make changes *before* you walk away, but too often digital camera users reason that they will make corrections on the computer when they get home. The adventure of learning how to see must begin—and should most often end—with creating the image inside the camera's viewfinder while the scene is still before you, *not* later on the computer screen.

[70–180mm lens, 1/125 sec. at f/8]

This day would be a struggle. After purchasing the red and yellow tulips, I soon found several bikes with character, and I was now ready to create a single image of bikes and tulips that captured the theme "Holland." With the tulips in place, I coaxed some pigeons into the scene by spreading bread crumbs on the ground (opposite, top). Using my 35–70mm lens, I made several exposures in spite of feeling that this was not the shot I had in mind; it was very busy. Several minutes passed, and I heard the sound of the oncoming trolley. "Of course," I exclaimed. "The trolley's yellow-and-red color will be a great complement in the background." After making that shot (opposite, bottom), I knew I had again fallen short. The composition was still too busy.

After several minutes of surveying all that was around me, I realized the need to simplify. Turning to the left and changing lenses did the trick. With my camera and 80–200mm lens on a tripod, I composed the flowers and portions of each bike against a background of water.

[Opposite, both photos: 35–70mm lens, 1/125 sec. at f/8. Above: 80–200mm lens, 1/60 sec. at f/11]

Breaking the Rules

Never place your subject in the center of the frame; it will create a static feeling. Never place your horizon line in the middle of the frame; it will create a feeling of indecision and negative tension. And, whatever you do, don't forget to always fill your frame—move closer or change to a longer focal length.

Don't you just love rules? As my parents will attest, I have always loved rules. Not so that I could follow them, but rather so that I knew where the boundaries were. That way, I could clearly see that I had crossed a boundary and could take delight in knowing that I was clearly breaking a rule. Fortunately, my rebellious phase didn't last too long. Had it gone on much longer, I very well might not be writing photography books but instead standing in front of a judge.

There are always exceptions to the guidelines I've covered in this chapter. You don't always have to follow the rules. They are just suggestions. Sometimes, a subject looks best centered in the frame. Sometimes, a horizon line that divides a picture directly in half works. There is a certain importance in not always relying on rules, otherwise you might not develop confidence in your vision when it differs from that of others. Take a look at these rule breakers and decide for yourself.

Large tidal pools, big rain puddles, ponds, and lakes all lend themselves to shooting reflections that often require splitting the frame into two equal parts, contradicting the never-place-the-horizon-line-in-the-middle-of-the-frame rule. So, with my tripod-mounted camera, I chose a low viewpoint, and although the frame is divided equally in half by the horizon line, the rule of thirds is in use: The image is broken into horizontal thirds—bottom third, reflection; middle third, cows and land; top third, sky.

[17–35mm lens, 1/30 sec. at f/16]

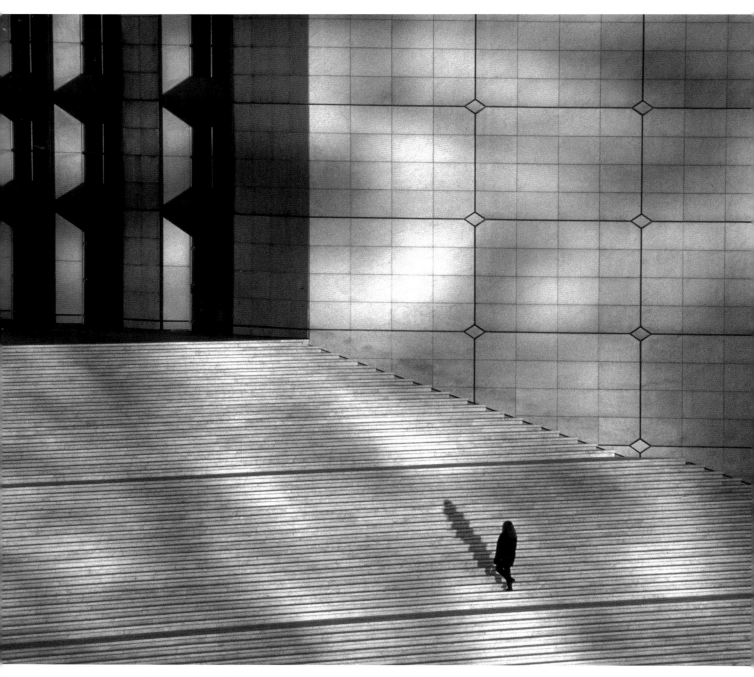

How can such a tiny subject grab your attention when it doesn't even come close to filling the frame? The answer lies in a basic law of visual perception: The smaller a subject is in relation to its surroundings, the more unusual it appears; and, the more unusual it appears, the more it stands out. This is similar to disrupting a pattern (see the lower image on page 71): Whatever interrupts the pattern then becomes the focus of attention.

On closer inspection, this image is, in fact, filled to the edge of the frame with contrasting tones and shapes. Since the woman walking up the steps (of La Defense in Paris) jumps out in contrast to the surrounding tones and shapes, she becomes the focus. If you were to place a lone figure anwhere inside this frame, you would achieve the same effect—the figure would always remain the point of interest. I also made a number of compositions that had upward of ten people in them, and the overall impact was subsequently diminished.

[300mm lens, 1/125 sec. at f/8]

Another common no-no is the bull's-eye effect—a composition with a key subject that is dead center. However, this picture is evidence that centering is not always bad. Shortly after my daughter Chloe had her face painted by the local clown at a festival in the small village of Oingt, France, she and I paid a visit to the town's church. She had taken a seat in one of the wooden chairs and was soon staring at a large stained glass window over my shoulder. She was so entranced that she honestly didn't notice I was taking her picture. She is dead center in the composition, but the random pattern of chairs behind her does a great job of eliminating the static feelings that usually are the result of a centered subject.

[35–70mm lens at 35mm, 1/30 sec. at f/4]

This puddle is right in the middle, but the picture works. It's another good "exception" example.

[80–200mm lens at 200mm, 1/30 sec. at f/22]

THE MAGIC
OF LIGHT

Available Light

What is available light? Simply put, it is the natural light that is available to make an exposure. It is never light from flash, strobes, or other studio lighting—that is artificial light. Available light is constantly changing as the Earth's position relative to the sun shifts throughout the day.

The time of day and your position vis-à-vis the sun determine a lot about how your subject will appear on film in available light: hard- or soft-edged, in warm or cool tones, and displaying vivid details or glaring contrasts. Light has three important characteristics: brightness, color, and direction. All three undergo varying degrees of intensity, again depending on the time of day, and each affects the mood created by the available light in any given scene. Careful study of these three attributes will enable you to take advantage of the powerful roles they play in establishing a photograph's emotional tone.

You must often pay a price for being passionate about presenting your subjects in the best available light possible. Arriving at a location long before the birds start singing may seem a bit crazy. Hanging out under the hot desert sun or ascending a mountain top in sub-zero temperatures to capture the special quality of light takes commitment. But, when you spread your slides across the light table or run your slide show across the computer screen, you will be reminded of why you made the effort!

Whenever I arrive someplace new to take photographs, I'm anxious to get my bearings: east, west, north, and south. I've had great success by visiting tourist shops in the airports and bus stations, where I buy postcards and those local souvenir picture books; then, I go looking for a cab driver, hotel concierge, or even the locals sitting on a park bench, and with my map in hand, I ask where the various pictures were taken. Then, I spend the midday hours looking for fresh viewpoints of those same subjects. If everything goes as planned, I then photograph them under the best possible light—early A.M. or early P.M. depending on the subject and its location. Scouting for compelling images at midday takes commitment, of course. Normally, this is the time to shop, be poolside, or simply sit under a tree reading a book. But there's nothing worse than being caught off guard and discovering a great shot at the wrong time of day with the wrong light.

The more experience you get working on location with available light, the better your photographs will be. You'll learn to assess a subject's potential under various lighting conditions, regardless of the light in which you initially see it. Even a daily awareness of the light around you—in the city, suburbs, countryside, or wherever you may live—will bring you closer to learning to see creatively.

Exercise: The Quality of Light

Try this exercise, which will reveal what is really meant by the *quality* of the light. Staying as close to home as possible, find a location that lets you face *east* and head there in time for the sunrise. With your street zoom (see page 26) set to a focal length near 35–50mm, shoot a composition into the sunrise. Shoot the same composition one and two hours later, then at noon, then two hours before sunset, then one hour before sunset, and finally at sunset.

Repeat this exercise during these same intervals with another composition but as you face to the *south*. At the end of the day, if you're working digitally, download the images to the computer and fire up a slide show. If you're using slide film, spread the images across the light table once they're processed, or out on a table if you're shooting color print film. Independent of subject matter, you will really see and feel the difference of the light and the difference that the "right" time of day can make.

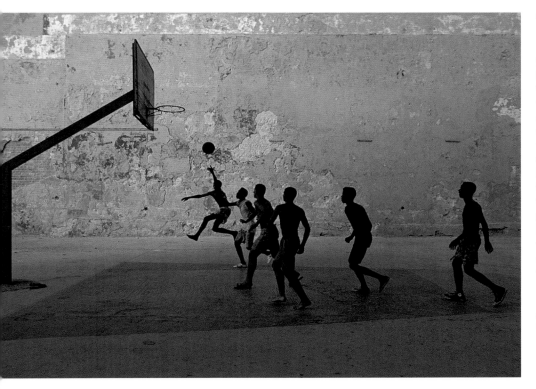

While walking the streets of Havana, I came upon these young boys playing basketball. Although I proceeded to shoot several frames, I wasn't at all happy with the cloudy light (top). When I left the court to peer down a nearby street, I saw that the clouds to the west were breaking up, so I returned to the game, knowing that soon the court would be aglow in gold light. Fortunately, the boys kept playing even though my much-hoped-for light didn't arrive for thirty-five minutes (bottom).

[Top: 17–35mm lens, 1/250 sec. at f/5.6. Bottom: 17–35mm lens, 1/250 sec. at f/11]

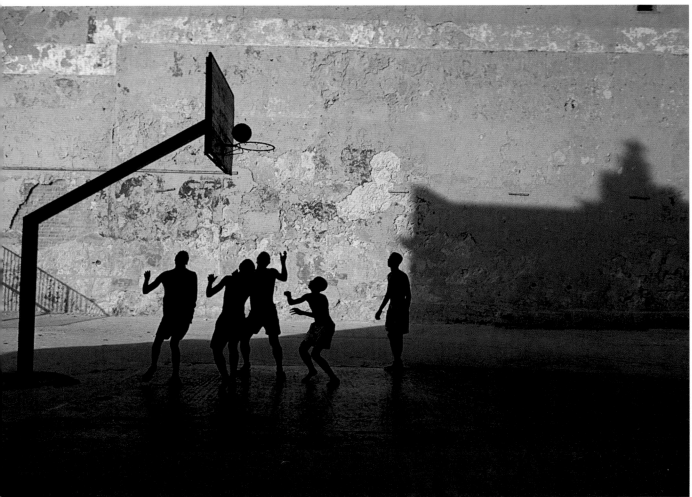

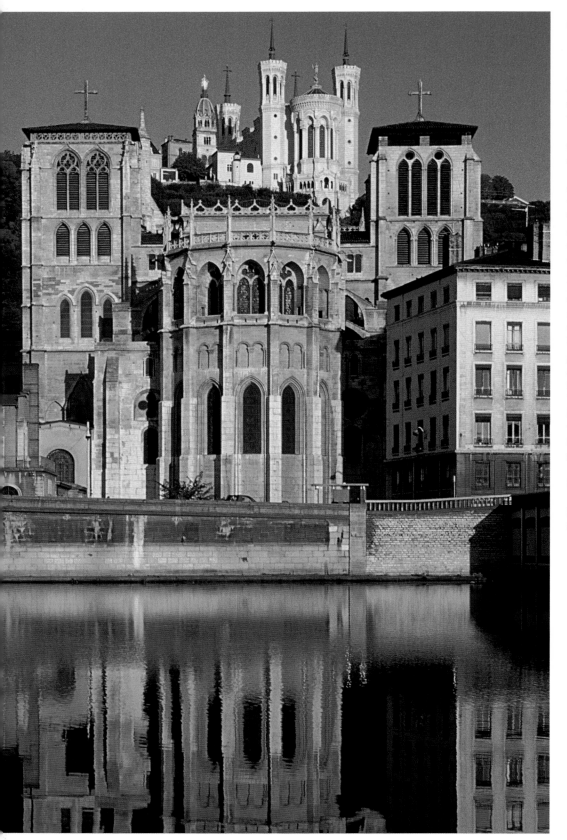

Shortly after my move to Lyon, France, I paid a number of visits to the postcard racks. Although I saw numerous night exposures of the famous St. Jean church, I didn't see any daytime shots of the same thing. "Perhaps the light is no good for this location *except* at night," I thought to myself. Since I prefer to find out for myself, I put this location on my "to do" list and a week later arose at 4:30 A.M., packed up my gear, and headed out the door. Arriving at the edge of the river Saône a few minutes before sunrise, I set up my tripod and camera. Fifteen minutes following sunrise, the light of early morning began to paint its warm glow across the top of the scene as if it were a giant roller paintbrush, continuing its downward stroke until, at last, the light reached all the way down to the river. I also returned to make an exposure at night (opposite).

[Left: 20–35mm lens at 20mm, 1/60 sec. at f/16. Opposite: 20–35mm lens at 20mm, 8 seconds at f/16]

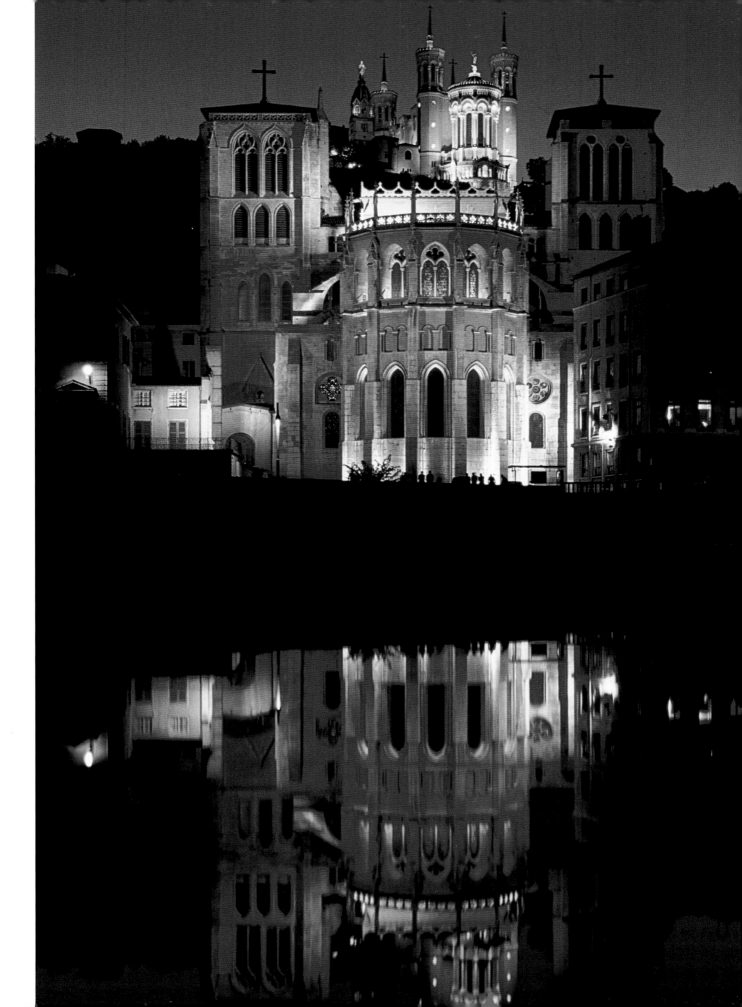

The Direction of Light

When the sun is low in the sky, whether in morning or late afternoon, your subject will be either frontlit, backlit, or sidelit, depending on your position relative to both your subject and the sun. *Frontlighting* occurs when the sun is at your back and hits the front of your subject. Note that this is not the time of day or light in which to shoot frontlit landscapes with a wide-angle lens, as your shadow will intrude into the composition and be captured by the wide, sweeping vision of the lens. To avoid having your shadow appear in the image, you must either wait until the sun is higher in the sky, use a normal or telephoto lens, or change your position and consider shooting the scene in sidelighting.

Sidelighting is by far the most dramatic, as it creates an exciting tension between highlights and shadows. It occurs when the sun is to the side of both you and your subject. Sidelighting produces shadows that bring a wonderful sense of depth to a scene, and it also emphasizes subject texture.

If you want to get your face suntanned while working, then backlit subjects are for you. *Backlighting* occurs when the sun hits the back of your subject and falls directly on your face as you photograph—you can't shoot backlighting unless you are facing right into the sun. Most backlit subjects are rendered as silhouettes. In effect, backlighting reduces your subjects to stark, dark, bold shapes. It is not limited to early morning and late afternoon light; you could easily position yourself under a power line at midday and photograph straight above you into the sun to silhouette the fifty-plus blackbirds perched on the line. Transparent subjects—such as leaves, feathers, and balloons—are also exciting subjects for backlighting, as the illuminating effect will showcase any intricate details and colors.

The daylight image of the church of St. Jean on page 132 is a good example of frontlighting, while this baby in a bicycle basket illustrates sidelighting. Note the texture of the basket and the brick wall, both highlighted by the direction of the light. The images of Big Sur on pages 136–137 are also perfect examples of sidelighting at different times of day.

[35–70mm lens at 35mm, 1/250 sec. at f/8]

Both images opposite illustrate backlighting. The machinery in the industrial image is opaque, producing a silhouetted effect, while the details of the transparent seed head are highlighted by the backlighting.

[Opposite, top: 80–200mm lens at 200mm, 1/250 sec. at f/11. Opposite, bottom: 105mm lens, 1/60 sec. at f/22]

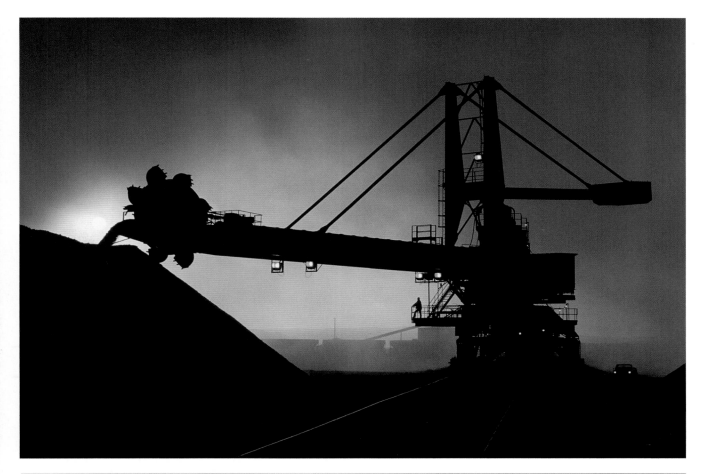

The Color of Light

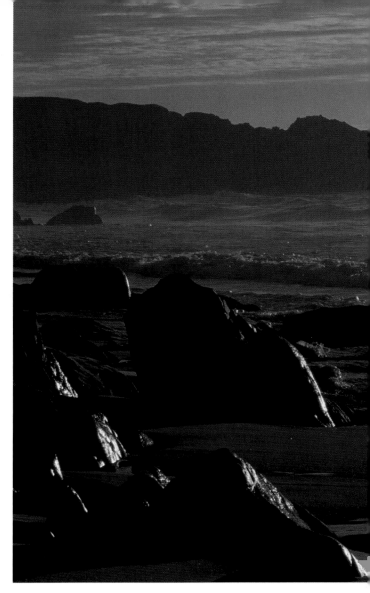

The color of daylight varies according to both the time of day and the weather. The midday sun produces an often harsh, white light. The overhead position and colorless quality of this light mean you are least likely to capture emotion-filled and dramatic lighting at this time of day, which is why so many experienced photogaphers prefer to shoot in the early morning and late in the day.

Just before dawn (and for about twenty minutes after sunset) in good weather, the light produces a clear sky with cool blue and magenta hues or rosy pinks and vivid reds. Beginning right at sunrise this is replaced with an unmistakably warm, orange light that bathes frontlit and sidelit subjects in various tones of orange and gold. Usually beginning about one hour before sunset and lasting up to sunset itself, this color change occurs in reverse. This sunset time is referred to by many photographers as *the golden hour,* implying that this is truly the most magical hour of the day for shooting.

I would agree with this if I hadn't made a regular habit of rising at dawn to see morning light, too. Having photographed numerous subjects during the *morning* golden hour as well as the sunset golden hour, I can say that both are magical times to work. Yet, what I have found interesting is that when I share my work with fellow pros, the almost universal response is, "It's obvious that, like me, you favor the last hour of daylight." I know I am not the only one who has discovered that morning light has a golden hour, too, but evidently there are still a lot of photographers out there who don't realize it. Truth be told, I've noticed that most photographers aren't morning people, and that's too bad since making a habit of taking pictures in *both* of the day's golden hours, day in and day out, will produce twice as many winners.

Sunrise light bathes Big Sur, California, in a golden light (above), while predawn and post-sunset light produces a range of rich reds, pinks, magentas, and blues (right). I consider *both* times, not just sunset, to be *golden hours.*

[Above: 80–200mm lens at 100mm, 1/60 sec. at f/22. Right: 80–200mm lens at 100mm, 1 second at f/22]

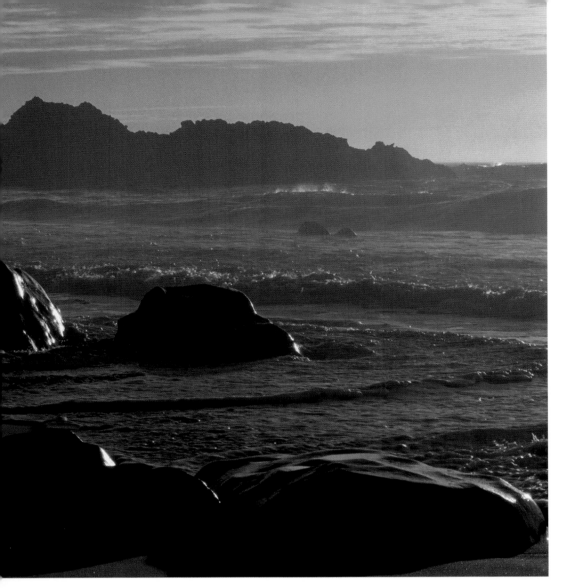

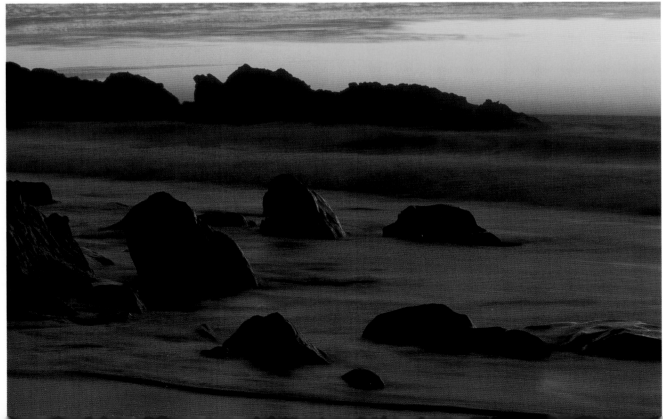

Overcast and Rainy Days

Although the argument for working only during the golden hours is a strong one, don't be seduced by it. There are countless opportunities to capture compelling subjects when the skies overhead are a sea of gray clouds, with or without rain. The much softer light of a cloudy day creates much richer colors, so this is a great time to shoot in your garden. Prove it to yourself by shooting some flowers on a cloudy day and then returning to shoot those same flowers when the sun is out. The results will speak volumes about the value of working under an overcast sky.

This is also a great time to photograph people. In this softer light, you don't need to worry about under-eye shadows or about your subjects squinting into the sunlight. Are you often frustrated by exposures of extreme contrast when working in the forest? Go on a cloudy day! In my opinion, sunny days are the worst time to be in the woods, since the combination of light and dark is often so extreme that no amount of bracketing will ever produce a compelling image. Save the forest for overcast days, and don't forget to use your polarizing filter. Particularly on rainy days, the polarizing filter will reduce, if not eliminate, much of the dull glare that reflects off the many wet surfaces in forests under those conditions. Rainy days are a magical time in cities, too. Colorful umbrellas abound, and the streets are a reflection lover's paradise.

The only things I would suggest avoiding when shooting on cloudy or rainy days are landscape or forest compositions that include too much of the gray sky. More often than not, the inclusion of a dull sky will only hurt the image, no matter how strongly you may feel it balances the composition. Why is this? Simply because the extreme shift in mood from the soft greens of the forest and trees to the harsh and glaring white/gray of the sky is far too contrasty. It's like listening to soft music while there's a constant scream in the background.

As rain began to fall on a location shoot for UPS, the art director called for a postponement. However, with my camera on a monopod, I decided to stand on a street corner and just see what happened. Not more than a few minutes later, two young women dashed by, and I was able to fire off several exposures while moving the camera from left to right. This technique is called *panning*, and the blurred effect is easily achieved by combining slow shutter speeds with a fluid and steady movement of the camera, following the direction of the subject's motion.

[80–400mm lens at 300mm, 1/15 sec. at f/16]

Scouting locations is something I almost always do in inclement weather or around midday, when the light is normally too harsh for picture taking. One such trip revealed a wonderful view of the German Alps and a small village from atop a high vantage point in a field. I made just one shot and also made a note in my journal adding it to my list of "Great Early A.M. Shots" under the subheading "Sunny Mornings."

Several days later the weather held the promise of some sun at dawn, so I headed back to that same spot a few minutes before sunrise. Although the sunrise was uneventful, I was rewarded nonetheless by strips of fog rolling through the scene. The sky remained mostly cloudy throughout the morning, so I opted to place a soft, magenta-colored graduated filter in front of the lens, positioning it so that only the sky and a portion of

the mountains were affected. The addition of this filter was an attempt to replicate the predawn magenta light that can often be found in the mountains. With my camera and lens on tripod, I set the focal length to 300mm, chose an aperture of f/16, and adjusted the shutter speed to 1/30 sec.

[Below: 75–300mm lens at 300mm, 1/125 sec. at f/16. Bottom: 75–300mm lens at 300mm, 1/30 sec. at f/16]

While double-parked and waiting for my wife to complete an errand, I picked up my camera and 35–70mm lens to photograph the weather while seated in the warm and dry confines of my car. With the car motor off and my elbows supported by the steering wheel, I raised the camera to my eye and filled as much of the frame as I could with the rain-soaked windshield. I then set my aperture to f/16 and, using the depth-of-field button, determined that this aperture would render the background street as an out-of-focus but very important and definable picture element. I adjusted the shutter speed to 1/8 sec. and very carefully depressed the shutter release for several frames.

[35–70mm lens, 1/8 sec. at f/16]

DIGITAL
PHOTOGRAPHY

In the photography industry, more changes and advances have been made in the past five years than in the past one hundred. The entire photographic process is in the midst of a vast and permanent change—digital image making will be king! Old-timers (like me), who grew up with totally manual film cameras, now find themselves in the same sandbox playing alongside those who bought their first cameras only six months ago.

I could not be more excited about the coming months and years. With all of the new and anticipated technology, the making, recording, and delivery of digital imagery will get even faster, easier, and cheaper. I would have to be a lousy businessman to turn my nose up at any technology that promises to increase both my work flow and my image quality.

On the market today you can find an array of digital cameras and related accessories. Most of these cameras come with a picture screen that can offer instant confirmation of a good or bad exposure or composition. They also offer instant gratification: Within, literally, seconds following your child's birthday party, you can download the images to the computer and begin making prints—even before the first parents arrive to pick up their kids. And then, out the door they go, with a color print in hand. Film shooters must wait a few days, if not weeks, to share those memories with everyone. They have to make two trips to the film processor: once to drop the film off and once to pick the prints up (that's aside from buying the film in the first place). And, they may have to go back a day or two later to order extra prints. Is it any wonder that in 2002 the sales of film cameras lagged behind those of digital cameras?

So, is there a downside to shooting digitally? If you are serious about someday "turning pro," most of today's digital cameras are not quite up to meeting the challenges you'll face, namely in their file size. Most of the file sizes today are still too small to produce two-page (spread) images in magazines or corporate reports. However, the Nikon D1X and D100, the Canon EOS 1-D, the Fuji Finepix, and Kodak's DCS 14N do offer a large enough file size of at least 5.5 MB—but at a price, of course. Additionally, new lenses are being designed to accommodate the smaller sensor size of many SLR digital cameras. So the prospect of shooting with a film camera over the next five years does seem to be an unlikely scenario. It's my prediction that within two years SLRs with file sizes of over 6 to 8 megapixels will be mass-marketed at well under $1000.

Currently, the mechanics of many non-SLR digital cameras don't allow for a real-time "shutter." This lag time in recording the actual exposure can, often, spell the difference between getting the shot and not getting it. Most non-SLR digital cameras offer far too much depth of field, even when using wide-open apertures. Creating zooming motion effects at slow shutter speeds is next to impossible since digital cameras with zoom lenses don't let you zoom in or out manually—you push and hold the button and wait for the camera to reach the desired focal length.

As I've mentioned, I am not a big fan of sitting at the computer and working on images. I still love to be behind the camera, putting my efforts to work there—*in camera*. I am concerned that today's amateur photographers, already achieving instant gratification with their digital cameras, are being seduced by the promise of image-software programs that—no matter the problem—can fix it! The message is, Just shoot away, no worries, and then when you download images to the

computer you can fix the problem there. Want some golden-hour light in an image shot at high noon? No problem, you can add the right colors on the computer, and who cares if the golden-hour shadows are missing? Want to make a close-up photograph without using macro equipment? No problem, you can crop in close on the computer.

Like any activity, photography should be fun and also challenging. The rewards of meeting photography's challenges are all part of the fun and, ultimately, the photographer who knows what is going on while working *behind* the camera will benefit the most from all of today's rapid technological advances. There should also be no shame in knowing that a given idea or concept will require the aid of a computer and photo-imaging software. It makes the whole photographic process behind the camera not only fun again, but it also can open up a visual world of amazing possibilities.

I originally shot this iguana as part of an assignment for Kodak. We were working at a small airport in Wallace, California, and nearby was an airplane painted bright yellow. I asked the animal trainer to place the iguana on the bright yellow wing and, looking down on the iguana from above, composed this graphic composition emphasizing line (opposite).

Almost a year later, I scanned this same image into Photoshop and began to "play." I limited myself to the Hue/Saturation, Brightness/ Contrast, and Paint Bucket controls. I didn't feel it was necessary to remove anything, but rather to add some color and "pump up the volume" (left). Following the placement of this image in a national advertising book for photographers, I made stock sales to a host of clients that so far have totaled more than $10,000. I should add that this is not an image I keep in my portfolio, as it is too far of a departure from my normal style and approach.

[35–70mm lens, 1/125 sec. at f/16]

How I Use Photo-Imaging Software

Have I given the impression that any kind of photographic manipulation after the image has been recorded is a big, giant *no-no*? If so, I apologize—as that is clearly not the case. Both photographers with years of experience and those just beginning should, when necessary, make use of the imaging programs available today.

What have I determined to be necessary? That for photographers who don't yet use a digital camera, photo-imaging software can be a godsend in correcting bad exposures made on film. All film shooters have images that could go from ho-hum to striking by a change in the overall exposure, or even by the removal of unwanted items such as distracting power lines or objects sticking out of a subject's head. This idea of removing elements is certainly not limited to those using film; digital photographers, too, can certainly benefit from this technique.

As a strong believer in doing what's necessary to make the composition work (for example, exchanging one potted plant for another), I would also be in favor of making changes in your photographs via a software-imaging program. However, I do want to stress that the changes I'm talking about are not akin to a 100-percent makeover. Instead, they are limited to touch-ups. The basic components of the composition do not change; rather, color is adjusted, distracting objects are removed, and exposures are corrected.

Again, I want to stress my own approach to image making. I will always invest 100 percent of my time in creating the image in-camera. If it should become necessary to make changes with a photo-imaging software program, the chances are good that those changes will be limited to removing an immovable object that, no matter my point of view, I could not eliminate in-camera. Another possibility may be when creating an image in which I want to emphasize a very grainy, texture-filled subject; I can do this after the fact by adding "noise" (a grainy texture effect normally associated with high-speed films).

Finally, without photo-imaging software (i.e. Photoshop), I could never do the amount of desktop publishing that I've done. From promotional cards to books, these software programs allow me to prepare all of my images for printing and publication. That, in and of itself, is more than enough reason to embrace this digital age.

In northern Bavaria, Germany, I came upon this autumn scene. As much as I liked the simplicity and color of the composition, I still felt that it would benefit from several filter effects that Photoshop offers. I combined the Diffusion filter with the Noise effect filter and the resulting image better conveys the more sensual and painterly feel that I wanted to achieve.

[80–200mm lens, 1/8 sec. at f/32]

Try as I might, I could not eliminate the lone power pole in this very busy landscape made near the Swiss-French border. So after shooting the scene, I reasoned that this would be a candidate for Photoshop.

As you can see in the image to the right, there is quite a change, yet my adjustments were limited to three things: With the Cloning tool, I removed unwanted subject matter, including fences and some trees; with the Hue/Saturation tool, I switched the image's gray tones to a sepia color; and, with the Noise effect filter I added grain to the overall composition to get the look of a high-speed film, such as ISO 1000.

[300mm lens, 1/8 sec. at f/22 for a +1 overexposure]

H aving arrived at this location earlier in the day, I eagerly waited for the late-afternoon light to cast its magenta hues across the French Alps. I had already set up my camera and lens on a tripod, and as the light show began, I made a number of exposures and varied compositions of the dark barn, all the while *knowing* that this image would end up in Photoshop chiefly for one reason: I would need to add some windows and the corresponding indoor illumination that is normal for a lived-in "chalet." If I hadn't done this, I would have ended up with a structure that looked abandoned. The lived-in look increases the salability of the photo—it's now a travel/vacation/cozy-solitude image.

With the aid of my Paintbrush tool and the color palette, I mixed red and yellow, and literally drew the windows and illumination into the sides of the storage barn. Voilà! It was no longer a storage barn but a lucky person's mountain getaway. At the time, I knew this image held great promise as a stock photograph. In its first year in the marketplace it has already earned more than $8,000 from varied clientele. Without the aid of my computer and the related software, this image would have remained in the "if only" file.

[80–400mm lens at 300mm, 1/15 sec. at f/16]

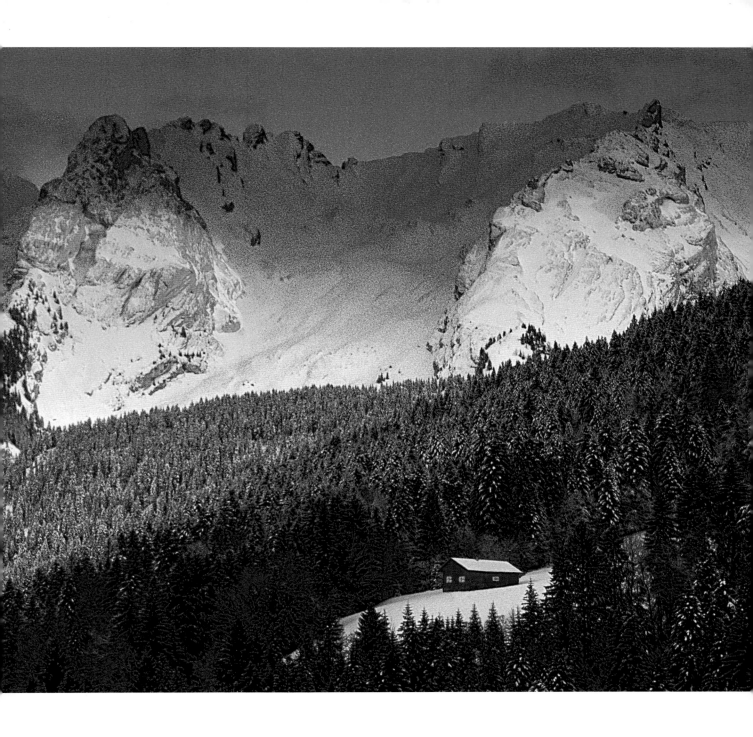

CAREER CONSIDERATIONS

With the wallet in place, I chose a low viewpoint (wallet level) and asked the couple to simply walk away from the bench so that it would be clear they were leaving.

[35–70mm lens at 35mm, 1/60 sec. at f/11]

What's Important

If your idea of being a photographer is "fun and fancy-free," you'd be right—some of the time. It is, like most professions, hard work. But, hey, if you've got to work hard, why not work hard at something you love to do?

Although most photographers start out their careers as studio photographers, location photographers, corporate photographers, wedding photographers, fashion photographers, advertising photographers, nature photographers, or newspaper photographers, over time many of them rise above the others and become known for their "unique use of light" or their "strong and graphic landscapes" or their "sensitive bridal portraits" or their reputation of "getting the shot at any cost" or their "wacky approach." Getting known is half the battle. The job that then remains—and will always remain, I might add—is the need to continually reinvent yourself. What I mean by that is this:

1. Constantly striving to look at the world from new vantage points

2. Consistently employing fresh points of view with all of your lenses

3. Always, always thinking of ideas that, when put on film or digital film card, demonstrate your skills at *visual problem solving*

Let me give you just one example of how this works. Let's say you have to convey the idea of someone losing a wallet. How would you go about communicating this? Unlike shooting a thirty-second television spot, you must do this with a single image. Although there are certainly a number of solutions, you must strive to find the most successful one. I chose what you see here.

Some Advice for the Aspiring Professional

1. Do what you do—and do it well—and you'll have plenty of competition.

2. Do what you do—and do it better than most—and you'll command an audience.

3. Do what you do—and do it better than anyone else—and you'll have the world at your doorstep.

Why the Constant Challenge?

The reason I find it necessary to be constantly challenging myself visually is twofold. First: All photographers rely heavily on their portfolios to get work, so it only makes sense to keep one's portfolio updated with new material. It creates a great reason to make return visits to clients, both clients for whom I've worked in the past and clients for whom I wish to work in the future: "Hello, Ms. Jones. It's Bryan Peterson calling, and I have some new material I'd love to share with you. I know you will find it interesting."

The second reason for doing this is that many photographers, myself included, have contracts with stock photo agencies. Think of a stock photo agency as a retail store that offers images, both film and digital, in all ranges of subject matter. Clients on a tight budget who can't afford a photographer, or clients with a tight deadline, call on the stock agencies to fill their requests for photographs. These requests may be as simple as "a waterfall" (perhaps to be used as an advertisement for a water purification device) or may be as detailed as "two elderly women on a front porch, with the American flag on display, and one of the women is holding a cat" (perhaps to be used in a senior citizen's magazine for a story about the effect of pets on one's health as one ages). Requests can be limited to a single feeling: "We need any and all pictures that convey the feeling of *security*" (perhaps for an insurance company's direct-mail piece). By constantly challenging yourself, you will always have new material to submit to stock agencies.

The stock agency negotiates a rental fee for the use of a photograph depending on three things: (1) the image size; (2) how many times it will be used (for example, one time only or six times over a three-month period); and (3) where it will be used (locally, regionally, nationally, or worldwide). As a result, rental fees can range anywhere from $200 to as much as $10,000. The stock agency takes 50 percent of all sales made, and the photographer receives 50 percent of all sales made on a monthly basis.

As I drove along one of the hundreds of back roads in Holland, I came upon these children some distance from me out in a field of tulips. I wasted no time in getting my lens and camera out of the trunk, and mounting it on a tripod. Since the children were a great distance from me, I wasn't able to give them any kind of direction—not to mention that I didn't even know them. After several minutes and four rolls of film, the two kids headed from the field to a nearby parked car. I hurriedly packed up and also headed over to the car, where I introduced myself to their parents and asked for a signed model release with the promise of sending some color prints.

Within months of making this image available through my stock agency back in 1992, it had been sold more than a hundred times and generated over $41,000. The image on pages 128–129 has made over $48,000 in stock photography since 1995. The world of stock photography has gone through a number of changes in the past five years, not the least of which are a number of megamergers. However, there is one constant: One-of-a-kind images still make money, and sometimes, a lot of money.

[800mm lens, 1/125 sec. at f/8]

Choosing a Theme

There's no special formula to succeed in this business except, of course, for the one with which every successful professional photographer is most familiar: long days, long nights, great self-discipline, and a determination to stay the course no matter what—even when the light at the end of the tunnel turns out to be an oncoming train! One piece of additional advice I offer my students, particularly in my Internet photography marketing workshop, is this: Before you can focus, it might be a good idea to know what it is you will focus on; in other words, *choose a theme or themes*.

Our world is truly large, and it is filled with so much photographic opportunity that at times it can feel really overwhelming—so much so that when you go out with plans to shoot, you end up wandering around in a daze. With a theme in mind, amazing things begin to happen. You will feel focused, directed, and enthusiastic!

The choices in themes are no less in number than the stars in the sky. Perhaps you'll be that photographer who hangs out at truck stops, not to shoot trucker portraits but rather to direct your macro lens at the dead moths, butterflies, and other insects stuck to the truck grills and windshields. If the themes of architecture, lifestyle, business, industry, or sports are too broad, then refine your search. Try reflections, windows, eyes, hands, feet, shoes, tools, smiles, flowers in the rain, old-growth forests, barns, birds, airplanes, steelworkers, loggers, carnival people, cowboys, three-year-olds, castles, feathers, fruits, vegetables, butterflies, amusement parks, seasons, nudes, bridges, lighthouses, orchards, famous cities by day, famous cities by night, churches, cemeteries, windsurfers, rollerbladers, skateboarders, mountain climbing, cats, dogs, watches, gum ball machines, parking meters, doors, alleys, teenagers, education, playgrounds, roadside diners, ATM machines, people using cellular phones, graffiti, neon signs, waistlines, ashtrays, or doorbells.

Perhaps you're better suited to applying your visual problem-solving talents toward communicating certain emotions or feelings: safety, security, access, connection, risk, despair, noise, instability, caution, indifference, loss, stubbornness, elation, lethargy, ambition, abandonment, grief, or love. Challenge yourself further if you wish by shooting compositions that evoke these emotions *without* using any people in the images.

Once you've picked your theme, don't forget to "look at it" while on your belly, while on your back shooting up, while atop a ladder shooting down, with your wide-angle lens, with your street zoom in close-focus mode, with your telephoto framing it against a background of muted tones, in the light of early morning, in the light of late afternoon, shortly after dusk, as a silhouette, at slow shutter speeds, and in all seasons—and don't forget to incorporate and emphasize, whenever possible, the elements of design: line, shape, form, texture, pattern, and, of course, color.

What may appear to be a cute image of parakeets is actually meant to convey the theme of *indifference*. With my camera and macro lens on a tripod, I zoomed the lens to 160mm, filling the frame with the five parakeets and also recording my wish that the center parakeet would *not* turn around to face me.

[70–180mm lens at 160mm, 1/250 sec. at f/5.6]

Index